Aesthetics and
Its Discontents

Aesthetics and Its Discontents

Jacques Rancière

Translated by Steven Corcoran

polity

First published in French as *Malaise dans l'esthétique* © Editions Galilée, 2004
Reprinted 2009 (thrice), 2010

This English edition (with minor revisions) © Polity Press, 2009

Liberté • Égalité • Fraternité

RÉPUBLIQUE FRANÇAISE

This book is supported by the French Ministry of Foreign Affairs, as part of the Burgess programme run by the Cultural Department of the French Embassy in London. (www.frenchbooknews.com)

Ouvrage publié avec le concours du Ministère Français de la Culture – Centre national du livre

Published with the assistance of the French Ministry of Culture

Polity Press
65 Bridge Street
Cambridge CB2 1UR, UK

Polity Press
350 Main Street
Malden, MA 02148, USA

ISBN-13: 978-0-7456-4630-5
ISBN-13: 978-0-7456-4631-2(paperback)

A catalogue record for this book is available from the British Library.

Typeset in 11 on 13 pt Sabon
by SNP Best-set Typesetter Ltd., Hong Kong
Printed and bound in the United States by Odyssey Press Inc., Gonic, New Hampshire

For further information on Polity, visit our website:
www.politybooks.com

Contents

Translator's Note

Readers not already familiar with Rancière's work will, I hope, be enticed by the trenchancy of his writing, which I have strived duly to render. This trenchancy is in part won with an idiosyncratic array of concepts, a good glossary of which can be found in the English edition of Rancière's *Politics of Aesthetics: The Distribution of the Sensible*, translated and introduced by Gabriel Rockhill. Despite the unusualness of these concepts, however, they are not essentially difficult to translate. The only term which, not being adequately translatable, I have left in French throughout is *dispositif*. The context of usage is that of *dispositifs* of art, and even, for example, of contemporary art itself as the name of a *dispositif*. An artistic *dispositif* is thus not only an arrangement of elements – e.g. a particular art installation or artistic device; a particular installation itself is part of a *dispositif* in the sense that it is deployed within a 'system' or 'plan of action'. Informing the arguments in *Aesthetics and Its Discontents* is Rancière's view that there exist different *regimes* of art, i.e. systems or institutions of widespread prevalence that make it possible for certain things to appear as art. So, he can claim that 'contemporary art' is a *dispositif* of what he calls the 'aesthetic regime of art', insofar as it involves a set of decisions and plans of action to have art *appear* in a specific way, one that makes sense only within this regime.

Acknowledgements

My profound thanks are due to those who helped me with the preparation of the manuscript. Gene Ray's kind reading through of the translation, and extensive knowledge of the field, afforded many stimulating discussions. The staff at Polity Press always provided encouragement and good cheer; I thank them warmly for their commitment to the project. Ruth Thackeray's meticulous and insightful editorial work gave the translation an inestimable fine-tuning. Lastly, my abiding thanks go to Jacques himself for his enthusiastic support and friendship over the years.

Introduction

Aesthetics has a bad reputation. Hardly a year passes by without a new book proclaiming either that its time is over or that its harmful effects are being perpetuated. In either case the accusation is the same. Aesthetics is charged with being the captious discourse by which philosophy, or a certain type of philosophy, hijacks the meaning of artworks and judgements of taste for its own benefit.

Though the accusation is constant, its grounds vary. Twenty or thirty years ago, the thrust of the trial could be summed up in Bourdieu's terms: namely, that 'disinterested' aesthetic judgement, Kant having set down its formula, is the site *par excellence* of the 'denegation of the social'.[1] Aesthetic distance, it was claimed, served to conceal a social reality marked by a radical separation between the 'tastes of necessity', affiliated with the popular habitus, and the games of cultural distinction reserved for those who had the means for them. In the Anglo-Saxon world, the same inspiration motivated works on the cultural or social history of art. Some showed us that behind

[1] Pierre Bourdieu, *Distinction: A Social Critique of the Judgement of Taste*, trans. Richard Nice, Cambridge, Mass.: Harvard University Press, 2007 (French original, 1979).

pure art's illusion and avant-garde proclamations there exists a reality of economic, political and ideological constraints laying out the conditions for artistic practice.[2] Others hailed the advent of the postmodern as inaugurating a break with the illusions of avant-gardism.[3]

This form of critique has almost totally gone out of fashion. For twenty years now, dominant intellectual opinion has unceasingly denounced all forms of 'social' explanation for their ruinous complicity with the utopias of emancipation, adjudged responsible for totalitarian horror. And, just as it sings of the return of pure politics, it celebrates anew the pure encounter with the unconditioned event of the work. One could have thought that this new turn of thought would clear aesthetics of wrongdoing. Apparently, this is not the case. The accusation was simply turned around. Aesthetics came to be seen as the perverse discourse which bars this encounter and which subjects works, or our appreciations thereof, to a machine of thought conceived for other ends: the philosophical absolute, the religion of the poem or the dream of social emancipation. This diagnosis can easily be underpinned by antagonistic theories. Jean-Marie Schaeffer's *Adieu à l'esthétique* (2000)[4] in this sense echoes Alain Badiou's *Petit Manuel d'inesthétique* (1998). Their respective types of thinking are nonetheless antipodal to one another. Schaeffer, basing himself on the analytic tradition, mounts a distinction between the concrete analysis of aesthetic attitudes and the erring way of speculative aesthetics. This

[2] Among the numerous works published in this vein by social and cultural art historians, there are two particularly notable books by: Timothy J. Clark, *The Absolute Bourgeois: Artists and Politics in France, 1848–1851*, London: Thames and Hudson, 1973; and *Image of the People: Gustave Courbet and the 1848 Revolution*, London: Thames and Hudson, 1973.

[3] Hal Foster, ed., *The Anti-Aesthetic: Essays on Postmodern Culture*, New York: The New Press, 1998.

[4] Jean-Marie Schaeffer, *Adieu à l'esthétique*, Paris: Presses Universitaires de France, 2000.

latter he thinks replaced the study of aesthetic conducts and artistic practices with a romantic concept of the artistic absolute so that it could resolve the false problem tormenting it: the reconciliation of the intelligible and the sensible. Badiou, for his part, starts out from wholly opposite principles. In the name of the Platonic Idea of which artworks are events, he dismisses a type of aesthetics which subordinates their truth to an (anti-)philosophy that is caught up in romantic celebrations of the poem's sensuous truth. Even so, the latter's Platonism and the former's anti-Platonism are one in denouncing aesthetics as a confused type of thinking involving a Romantic confounding of pure thought, sensible affects and artistic practices. To this 'confusion' both thinkers respond by proposing a principle of separation that puts elements and discourse in their respective places. In defending, against 'philosophical aesthetics', the rights of (the good) philosophy, they still mould themselves on the discourse of the anti-philosopher sociologist, contrasting the reality of attitudes and practices to speculative illusion. They are therefore one with dominant opinion, the main concern of which is to extract the glorious sensuous presence of art out from under the suffocating discourse *on* art which tends to become its very reality.

The same logic can also be seen in reflections on art grounded in other philosophies or anti-philosophies. In Jean-François Lyotard's work, for example, a contrast is set up between idealist aesthetics and the sublime strike of the pictorial line or of the musical timbre. All these discourses similarly criticize the confusion of aesthetics. At the same time, more than one of them gives us to see that aesthetic 'confusion' also involves another stake, whether it be: the realities of class division beneath the illusion of disinterested judgement (Bourdieu); a parallel between the events of the poem and those of politics (Badiou); the shock of the sovereign Other as opposed to the modernist illusions of thought as that which fashions a world (Lyotard); or a denunciation of the complicity between

aesthetic utopia and totalitarian utopia (the chorus of subcontractors). Conceptual distinction is not for nothing a homonym of social *distinction*. Clearly there are stakes linked to the confusions, or rather the distinctions, of aesthetics that concern the social order and its transformations.

The following pages make a simple argument against these theses of 'distinction': that the confusion they denounce, in the name of a thought that puts each thing in its proper element, is in fact the very knot by which thoughts, practices and affects are instituted and assigned a territory or a 'specific' object. If 'aesthetics' is the name of a confusion, this 'confusion' is nevertheless one that permits us to identify what pertains to art, i.e. its objects, modes of experience and forms of thought – the very things we profess to be isolating by denouncing aesthetics. By undoing this knot so that we can better discern practices of art or aesthetic effects in their singularity, we are thus perhaps fated to missing that very singularity.

Let us take an example. Schaeffer wants to denounce the confusion from which Romanticism suffers by showing us that aesthetic conducts are actually independent of the artworks and judgements to which they give rise. To this end he makes use of a brief passage from Stendhal's autobiographical *Vie de Henry Brulard* (1835), in which the author evokes the first – insignificant – noises that marked him as a child: ringing church bells, a water pump, a neighbour's flute. Schaeffer compares these memories with those of a Chinese writer, Shen Fu, who wrote of the mountains he saw in molehills while lying on the ground as a child. In these memories, Schaeffer claims to see evidence of a cross-cultural 'aesthetic attitude' that is not directed toward artworks. However, they can just as easily be taken as proof to the contrary. Stendhal's contribution to the invention of a literary genre that works to blur boundaries – that of the life of the artist as work – established what was to become the exemplary form of new fictional narration: the juxtaposition of sensory micro-

2

events, forming a cross-temporal resonance that contrasts with the former chains of voluntary actions and of their desired and undesired effects. Far from demonstrating the independence of aesthetic attitudes with respect to artworks, Stendhal testifies to an aesthetic regime in which the distinction between those things that belong to art and those that belong to ordinary life is blurred. The raw noise of the water pump that, as a writer, he inserted in his autobiography is the very same that Proust held aloft as the strike of the new Platonic Idea, albeit at the price of fusing it with the song of Chateaubriand's thrush. It is also that of the air-raid sirens, introduced into a composition by Varèse in his *Ionisation*.[4a] It is this noise whose frontier with music has unceasingly blended in with music itself throughout the twentieth century, just as it blended in with the literary muses throughout the nineteenth.

Far from revealing the 'confusion' of aesthetic theory, Stendhal's water pump testifies precisely to something that this theory strives in its way to interpret: the ruin of the old canons that set art objects apart from those of ordinary life, the new form – at once more intimate and more enigmatic – taken by the relation between the conscious productions of art and the involuntary forms of sensory experience in which their effects are manifest. This is precisely what Kant's, Schelling's and Hegel's 'speculations' record: for the first, an 'aesthetic idea' and theory of genius as marks of the relationless relation between the concepts of art and the 'concept-less' character of aesthetic experience; for the second, a theorization of art concerning the unity of a conscious process and an unconscious process; and for the third, the metamorphoses of beauty between an Olympian god's blank gaze and the genre scenes of Netherlandish painting or Murillo's little beggars. In his reflections on the sensations he experienced as a young

[4a] *Ionisation* (1929–31) is scored for thirteen percussion instruments, some indefinite and others relatively definite in pitch; there are also two sirens, one high and one low.

child in the years 1787–8, Stendhal even obliges us by
saying what provided the background for such specula-
tions: namely, the new education of the senses informed
by the insignificant noises and events of ordinary life, pre-
cisely the type of education becoming of a young republi-
can, called upon to celebrate his age of reason in the era
in which the French Revolution would celebrate the reign
of Reason.

 To understand at once what 'aesthetics' means and
what motivates the animosity its name provokes today, the
arguments of anti-aesthetic discourse must therefore be
turned on their heads. This can be summed up in four
points.

 What aesthetic 'confusion' initially tells us is that there
is no such thing as art in general, no more than there are
conducts or aesthetic sentiments in general. Aesthetics was
born as a discourse two centuries ago. It was in this same
era that art, in its indeterminate singularity, was first set
in contrast to the list of fine, or liberal, arts. Indeed, if art
is to exist it is not enough for there to be painters or musi-
cians, dancers or actors. If aesthetic sentiment is to arise,
it is not sufficient that pleasure is taken in seeing or hearing
their work. For art to exist, what is required is a specific
gaze and form of thought to identify it. This identification
itself presupposes a complex process of differentiation. For
a statue or a painting to be adjudged art, two apparently
contradictory conditions are required. The work in ques-
tion must be seen as the product of an art and not as a
simple image that is to be judged solely in accordance with
the legitimacy of its principle or its factual resemblance.
But it must also be seen as something that is more than
just the product of an art, more than the rule-bound exer-
cise of a *savoir-faire*. Insofar as it is seen as the mere
accomplishment of a religious or therapeutic ritual, dance
is not an art. But nor is it if it consists merely in the exercise
of a corporeal virtuosity. Something else is required if it is
to be counted as an art. This 'something else' was, until
Stendhal's time, called a *story* [*histoire*]. For the theoreti-

So that means a consciousness a priori of thought?

cians of poetry in the eighteenth century, knowing whether or not the art of dance was one of the fine arts involved answering a simple question: does dance tell a story? Is it a *mimesis?* Mimesis, in fact, distinguished the artist's know-how as much from the artisan's as from the entertainer's. The fine arts were so named because the law of *mimesis* defined them as a regulated relation between a way of doing – a *poiesis* – and a way of being which is affected by it – an *aisthesis*. This threefold relation, whose guarantee was called 'human nature', defined a regime for the identification of arts that I have proposed to call the representative regime. The moment when art substitutes its singularity for the plurality of fine arts, and produces, in order to think it, the discourse that came to be called aesthetics, is the moment when a knot came undone: this knot had tied together a productive nature, a sensible nature and a legislative nature called *mimesis* or representation.

Aesthetics is above all the discourse that announces this break with the threefold relation enshrining the order of fine arts. The end of *mimesis* is not the end of figuration. It is the end of the mimetic legislation whereby a productive nature and a sensible nature were made to fit. With this end, the muses cede their place to music, that is to a relation without mediation between the calculus of the work and the pure sensible affect, which is also an immediate relation between the technical device and the song of inner life:[5] for

[5] 'But, from what sort of magic potion does the aroma of this brilliant apparition rise up? – I look, – and find nothing but a wretched web of numerical proportions, represented concretely on perforated wood, on constructions of gut string and brass wire. – This is almost more wondrous, and I should like to believe that the invisible harp of God sounds along with our notes and contributes the heavenly power to the human web of digits.' Wilhelm Heinrich Wackenroder, *Confessions and Fantasies*, trans. and with intro. by Mary Hurst Schubert, London: Pennsylvania State University Press, 1971, pp. 179–80 (German original, 1799). Elsewhere I have discussed the meaning of this 'apparition': cf. 'Metamorphosis of the Muses', in *Sonic Process: A New Geography of Sounds*, Barcelona and Actar: Museu d'Art Contemporani 2002.

1. mimesis, poiesis & aisthesis.

instance, the horn solo which forms the soul of Fiordiligi's words,[5a] but also the neighbour's flute and the water pump which shape the soul of an artist. *Poiesis* and *aisthesis* stand henceforth in immediate relation to each other. But they relate to one another through the very gap of their ground. They can only be brought to agree by a human nature that is either lost or by a humanity to come. From Kant to Adorno, including Schiller, Hegel, Schopenhauer and Nietzsche, the object of aesthetic discourse has only ever been to think through this discordant relation. What this discourse has thereby striven to articulate is not the fantasy of speculative minds, but the new and paradoxical regime for identifying what is recognizable as art. I have proposed to call this regime the aesthetic regime of art.

This brings us to the second point. 'Aesthetics' is not the name of a discipline. It is the name of a specific regime for the identification of art. Philosophers since Kant have attempted to grasp this regime in thought, but they did not invent it. When Hegel, in his *Aesthetik*, unfolds the history of forms of art as a history of the forms of mind, he takes cognizance of a contradictory mutation in the status of works.[5b] On the one hand, the discoveries of archaeology restore Greek antiquities to their place, and reinstate their distance by casting doubt on the classical age's conception of civilized Greece. With these discoveries, a new historicity comes to frame works, one made of proximities, of ruptures and of reprises, and which contrasted sharply with the normative and evolutionary model governing the classical relation of the Ancients to the Moderns. At the same time, however, paintings and sculptures were severed from their functions of religious illustration and of decorating seigniorial and monarchic grandeurs by a revolutionary rupture

[5a] The allusion here is to Fiordiligi's aria 'Come scoglio' from Mozart's opera *Così fan tutte* (1790).
[5b] Hegel, *Aesthetics: Lectures on Fine Art*, trans. T. M. Knox, Oxford: Oxford University Press, 2 vols., 1979 (German original, 1835–8).

which isolated them in the space of the – real or imaginary
– museum. This rupture accelerated the constitution of
a new, undifferentiated public to replace the designated
addressees of representative works. Furthermore, the
imperial and revolutionary pillaging of objects from con-
quered countries shook up the products of various schools
and genres. The effect of these displacements was to accen-
tuate the sensible singularity of works and to undermine
not only their representative value but also the hierarchy
of subjects and genres according to which they were classi-
fied and judged. Hegel's philosophical revalorization
of Netherlandish genre painting, following its public and
commercial promotion, signals the beginning of this slow
erosion of the figurative subject, of this century-long
movement that pushes the subject into the background of
the picture to make appear, in its place, the gesture of
the painter and the manifestation of pictorial matter. Thus
began the movement by which the picture was transformed
into an archive of its own process, preparing the way for
the spectacular pictorial revolutions of the following
century.

Similarly, when Schelling defined art as the union of two
processes, one conscious, the other unconscious, he con-
solidated the perspectival inversion contained in the advent
of 'philological' readings of poems – starting with
Giambattista Vico through to Johann Gottfried Herder
and Friedrich Wolf – as well as in cultural phenomena such
as the passion for the fake Ossian. Much more than as the
intentional realizations of an art guided by poetic rules,
the great poetic models came to be read as expressions of
an anonymous collective power. Jean-Marie Schaeffer pro-
fesses astonishment that, in its celebration of art, philo-
sophical aesthetics has forgotten something that Kant
himself had already emphasized: the importance of aes-
thetic conducts pertaining to the spectacles of nature. But
there has been no forgetting. Since Kant, aesthetics has
unceasingly endeavoured to think through the new status

of artworks, a status in which they are perceived as works of nature or, in other words, as the operation of a non-human nature not subject to the will of a creator. Many theorists have sought to associate the concept of genius with the sacredness of the unique artist; what it actually expresses, on the contrary, is this very equivalence between the willed and the unwilled, and the recognition and appreciation of works *of art* emergent with the ruining of criteria of perfection in *the arts*.

The philosophers who initiated aesthetics did not invent this slow revolution in the forms of presentation and perception in which works for an undifferentiated public are isolated and simultaneously linked to an anonymous power: people, civilization or history. Neither did they invent the break with the hierarchical order that had defined which subjects and forms of expression were deemed worthy of inclusion in the domain of a given art. They did not invent the new writing made up of sensory micro-events, that new privilege of the minute, of the instantaneous and the discontinuous to which the *Vie de Henry Brulard* attests, and which was accompanied by the introduction of every vile thing and person into the temple of art; this would mark literature and painting before enabling photography and cinema to become arts. They did not invent, in sum, all those reconfigurations of the relations between the scriptural and the visual, pure and applied art, and the forms of art and those of public or everyday commercial life – all of which define the aesthetic regime of art. They did not invent them but they did elaborate the regime of intelligibility within which they could be thought. They grasped and conceptualized the fracturing of the regime of identification in which the products of art were perceived and thought, the rupturing of the model of adequation between *poiesis* and *aisthesis* established by the norms of *mimesis*. Under the name of aesthetics, they above all grasped and conceived a fundamental displacement: namely, that the things of art would henceforth be identified less according to criteria of

'ways of doing', and more in terms of 'ways of sensible being'.[6]

These philosophers conceived this revolution as a challenge for thought. This is the third point: our contemporaries strive in vain to denounce the term aesthetics, since those who honoured it were the first to do so. 'It is time we got completely rid of that expression which, ever since Kant, is ever and always to be read in the writings of amateurs of philosophy, even though its absurdity has often been recognized. . . . Aesthetics has become a veritable *qualitas occulta* – hidden behind this incomprehensible word there are many nonsensical assertions and vicious circles in arguments that should have been exposed long ago.' This radical declaration is not the feat of a supercilious champion of Anglo-Saxon analytic philosophy. It features in the *Vorlesungen über Schöne Literatur und Kunst* (1809–11) by August Wilhelm von Schlegel, the elder of those diabolical brothers so gravely accused of being responsible for fostering the fatal illusions of speculative and Romantic aesthetics.[7] The discontent with aesthetics is as old as aesthetics itself. Hegel said, in his turn, that the word 'aesthetics', which refers to sensibility, is not appropriate for expressing thought about art, then adopting it again with the excuse that its use was so established. Yesterday's excuse is as superfluous as today's accusation. The in-appropriation is constitutive. Aesthetics is not a domain of thought whose object is 'sensibility'. It is a way of thinking the paradoxical sensorium that henceforth made it possible to define the things of art. This sensorium

[6] 'Aesthetics' designates two things in this work: a general regime of the visibility and the intelligibility of art and a mode of interpretative discourse that itself belongs to the forms of this regime. The context and its specific intelligence will suffice in what follows to indicate to the reader the sense of the word adequate to such and such an occurrence.

[7] August Wilhelm von Schlegel, *Vorlesungen über Schöne Literatur und Kunst*, in *Kritische Ausgabe der Vorlesungen*, 3 vols., Paderborn: F. Schöningh, 1809–11, vol. I, pp. 182–3.

is that of a lost human nature, which is to say of a lost norm of adequation between an active faculty and a receptive faculty. What has come to replace this lost norm of adequation is an immediate union: the concept-less union of the opposition between pure, voluntary activity and pure passivity. The origin of art, said Hegel, resides in the act of the child who skims stones, transforming the surface of the water, that of 'natural' appearances, into a surface for the manifestation of his lone will. But this child, who skims stones, is also a child whose artistic ability is born of the pure contingency of proximate noises, of the mixed noises of artless nature and material life. This child cannot be conceived in both aspects without contradiction. But whoever sets out to suppress the contradiction in thought thereby also suppresses art and the aesthetic sentiment that one believes one is preserving.

What complicates things and raises the stakes for thought is that a 'human' nature is always simultaneously a 'social' nature. This is the fourth point. The human nature of the representative order linked the rules of art to the laws of sensibility and the emotions of the latter to the perfections of art. But there was a division correlative to this linking whereby artworks were tied to celebrating worldly dignities, the dignity of their forms were attached to the dignity of their subjects and different sensible faculties attributed to those situated in different places. 'The man of taste', said Voltaire, 'has a different pair of eyes, a different pair of ears, a different sense of tact to that of the coarse man.'[8] Nature, which yoked works to sensibilities, tied them to a division of the sensible which put artists in their place and set those concerned by art apart from those that it did not concern. So, Bourdieu was right despite himself. The word 'aesthetics' says, in fact, that

[8] Voltaire; 'Goût', in *Dictionnaire philosophique*, Paris, 1827, vol. III, p. 279. (Bear in mind that the *Dictionnaire philosophique* cited here is a fictive collection. Most of the elements of this article on taste are in fact borrowed from the sixth part of *Questions sur l'Encyclopédie* of 1771.)

this social nature was lost along with the other one. Sociology was born precisely of the desire to reconstitute that lost social nature. The hatred of 'aesthetics' is, for this reason, consubstantial with it. Sociology in Bourdieu's time had doubtless left behind its original dreams of social reorganization. For the good of science, however, it has continued to desire what the representative order desired, for the good of social and poetic distinctions: that separate classes have distinct senses. Aesthetics is the thought of the new disorder. This disorder does not only imply that the hierarchy of subjects and of publics becomes blurred. It implies that artworks no longer refer to those who commissioned them, to those whose image they established and grandeur they celebrated. Artworks henceforth relate to the 'genius' of peoples and present themselves, at least in principle, to the gaze of anyone at all. Human nature and social nature cease to be mutual guarantees. Inventive activity and sensible emotion encounter one another 'freely', as two aspects of a nature which no longer attests to any hierarchy of active intelligence over sensible passivity. This gap separating nature from itself is the site of an unprecedented equality. And this equality is inscribed in a history, which, in exchange for the loss, carries a new promise. The young girl of whom Hegel speaks, the one who succeeds the Muses, offers us the fruits picked from the tree, the veiled memory, 'without effectiveness', of the life that carried the artworks.[9] But, precisely, these works are such only because their world, the world of nature fulfilling itself in culture, *is* no longer, or perhaps never *was*, except in the retrospection of thought. There perhaps was – no doubt there never was – a Greek morning on which the fruits of art collected on the tree of life. But with the loss of this hypothetical good, what at any rate began

[9] Georg Wilhelm Friedrich Hegel, *Phenomenology of the Spirit*, trans. A.V. Miller and with foreword by J.N. Findlay, Oxford: Oxford University Press, 1979 (German original, 1807). 'The girl who succeeds the Muses' is the title of an essay by Jean-Luc Nancy, who discusses this passage in *The Muses*, trans. Peggy Kamuf, Stanford: Stanford University Press, 1997, pp. 41–55.

to vanish was the order whereby a human nature that
legislates on art was tied to a social nature that determined
place in society and the 'sense' appropriate to that place.
The revolutionary reign of nature thereby becomes a vain
dream. But what emerges as a response to this impossible
dream is the promise carried by the loss itself, that is by
the suspension of the rules by which human nature is
accorded with social nature: the humanity to come, which
Schiller saw announced in aesthetic 'free play'; the 'infinite
taste of the Republic,' which Baudelaire sensed in the
songs of Pierre Dupont; the 'promise that we could not
live an instant without,' which Adorno saw renewed in the
very veil-wrapped sonority of the chords at the beginning
of Mahler's First Symphony.

 'Aesthetics' is the word that expresses the singular knot
that, posing a problem for thought, formed two centuries
ago between the sublimities of art and the noise of a water
pump, between a veiled timbre of chords and the promise
of a new humanity. The discontent and resentment that it
elicits today effectively still revolves around these two rela-
tions: first, the scandal of an art which, in its forms and
its sites of exhibition, welcomes the 'anything goes' aspect
of objects of use and images of profane life; and second,
the exorbitant and misleading promises of an aesthetic
revolution which endeavoured to transform art's forms
into the forms of a new life. Aesthetics is held responsible
both for the 'anything goes' aspect of art and for having
misled us with its fallacious promises of the philosophical
absolute and social revolution. My intention is not to
'defend' aesthetics but to contribute to clarifying what the
word means, insofar as it is a regime of the functioning of
art and a matrix of discourse, a form for identifying the
specificity of art and a redistribution of the relations
between the forms of sensory experience. More particu-
larly, the following pages set out to define the way in
which a regime for identifying art is linked to the promise
of an art that would be no more than an art or would no
longer be art. They seek, in a nutshell, to show how aes-

thetics, as a regime for identifying art, carries a politics, or metapolitics, within it. By analysing the forms and the transformations of this politics, they seek to understand the discontent or the resentment that the word elicits today. The stake here, however, is not merely to understand the meaning of a word. Tracing the history of aesthetic 'confusion' also involves trying to clarify another confusion that the critique of aesthetics fosters, one that buries art's operations along with political practices underneath the indistinctness of ethics. The stake here does not only concern those objects that fall within the sphere of art, but also the ways in which, today, our world is given to perceiving itself and in which the powers that be assert their legitimacy.

This book is based in part on seminars given between 1995 and 2001 at Université Paris-VIII and at the Collège International de Philosophie, and also on seminars and conferences that I have given over recent years at the invitation of many institutions, both in France and elsewhere. I provide some references in the book's footnotes. But to mention all the institutions and all the various occasions that enabled me to elaborate and amend the arguments presented here would unfortunately require too long a list. May all those who stimulated this work, and who welcomed it and discussed its results, please find in it the expression of my gratitude.

Politics of Aesthetics

Aesthetics as Politics

The same assertion is bandied about nearly everywhere today, namely the claim that we are over and done with aesthetic utopia, with a certain idea of artistic radicality and its capacity to perform an absolute transformation of the conditions of collective existence. This idea fuels all those high-sounding polemics pointing to art's disaster, born of its dealings with fallacious promises of social revolution and the philosophical absolute. Leaving these media squabbles aside, it is possible to distinguish between two great conceptions of art's 'post-utopian' present.

The first attitude is above all due to philosophers and art historians. It claims to be able to extricate artistic pursuits and creations from the aesthetic utopias of the new life, which compromised them, either in the great totalitarian projects or in the commercial aestheticization of life. Art's radicality here, then, is the singular power of presence, of appearing and of inscription, the power that tears experience from ordinariness. There has been a strong tendency to conceive this power in terms of the Kantian concept of the 'sublime' as the irreducible and heterogeneous presence at the heart of the sensible of a force that exceeds it.

However, this reference can be interpreted in two ways. The first sees in the singular power of the work the founding of a being-in-common, anterior to the various different possible forms of politics. Such, for example, was the meaning of an exhibition organized in Brussels in 2001 by Thierry de Duve under the title *Voici*, itself divided into three sections: *Me voici, Vous voici, Nous voici*. The key to this apparatus was provided by a canvas by Édouard Manet, the so-called father of pictorial 'modernity': not *Olympia* or *Le Déjeuner sur l'herbe*, but a work from his youth, the *Christ mort*, based on a work by Francisco Ribalta. This open-eyed Christ, resurrected by the death of God, turns art's power of presentation into a substitute for the communitarian power of Christian incarnation. This power of incarnation, ascribed to the very act of showing, then also proved transmittable to a Donald Judd parallelepiped, to Joseph Beuys' display of East-German butter packets, to Philippe Bazin's series of baby photographs or to Marcel Broodthaers' documents of a fictitious museum.

The other way, by contrast, radicalizes the idea of the 'sublime', construing it as an irreducible gap between the idea and the sensible. It is in this way that Lyotard sees the mission of modern art as being to bear witness to the fact of the unpresentable. The singularity of appearing is therefore a negative presentation. The monochromy of a Barnett Newman canvas cleaved by a lightning flash or the naked speech of a Paul Celan or a Primo Levi are, for him, the model of these inscriptions. Conversely, mixing the abstract and the figurative on trans-avant-gardist paintings, not to mention the hodgepodge of installations that play on the indiscernibility between works of art and objects or icons of commerce, represent the nihilist accomplishment of aesthetic utopia.

The idea that these two visions have in common is clear. The very opposition between the Christian power of incarnation of the word and the Jewish prohibition on representation, between the eucharistic host and the burning

Mosaic bush, reveals a dazzling, heterogeneous singularity of artistic form, one that commands a sense of community. But this is a community which builds itself on the ruining of perspectives for political emancipation to which modern art was able to link up. It is an ethical community which revokes every project of collective emancipation.

If this position has some favour with philosophers, it is quite another one that is keenly asserted by artists and professionals working in artistic institutions today – museum directors, gallery directors, curators and critics. Instead of making a contrast between artistic radicality and aesthetic utopia, this other position endeavours to keep the two equally at a distance. It replaces them with the proclamation of art's new modesty – it is modest not only as regards its capacity to transform the world, but also as regards claims about the singularity of its objects. This art is not the founding of a common world through the absolute singularity of form; it is a way of redisposing the objects and images that comprise the common world as it is already given, or of creating situations apt to modify our gazes and our attitudes with respect to this collective environment. Such micro-situations, which vary only slightly from those of ordinary life and are presented in an ironic and playful vein rather than a critical and denunciatory one, aim to create or re-create bonds between individuals, to give rise to new modes of confrontation and participation. The principle of so-called relational art here is exemplary: in contrast to the radical heterogeneity of the shock of the *aistheton* that Lyotard sees on a Barnett Newman canvas stands the practice of a Pierre Huyghe, who, instead of the advertisement that had been expected, registers on a billboard an enlarged photograph of the place and its users.

I do not intend to decide in favour of one or other of these two attitudes. Instead I want to examine what they testify to and what renders them possible. They are in fact the two strands that emerge by undoing the alliance between artistic radicality and political radicality, an

alliance whose proper name is today's incriminated term of aesthetics. Therefore, instead of deciding in favour of one of these positions, I will attempt to reconstitute the logic of the 'aesthetic' relation between art and politics from which they are derived. I will base my analysis on what both these ostensibly anti-aesthetic stagings of 'post-utopian' art have in common. In contrast to the denounced utopia, the latter proposes the modest forms of a micro-politics that is sometimes not far from the community politics advocated by our governments. The former, on the contrary, contrasts utopia with a power of art that ensues from its distance with respect to ordinary experience. Nevertheless, both positions are one in reasserting art's 'communitarian' function: that of constructing a specific world space, a new form of dividing up the common world. The aesthetics of the sublime places art under the sign of an immemorial debt towards an absolute Other. But it confers on it an historic mission, assigned to a subject it calls the 'avant-garde': to constitute a tissue of sensible inscriptions at an absolute distance from the world of products and their commercial equivalence. Relational aesthetics rejects art's claims to self-sufficiency as much as its dreams of transforming life, but even so it reaffirms an essential idea: that art consists in constructing spaces and relations to reconfigure materially and symbolically the territory of the common. *In situ* art practices, displace-ments of film towards the spatialized forms of museum installations, contemporary forms of spatializing music, and current theatre and dance practices – all these things head in the same direction, towards a despecification of the instruments, materials and apparatuses specific to dif-ferent arts, a convergence on a same idea and practice of art as a way of occupying a place where relations between bodies, images, spaces and times are redistributed.

The very expression 'contemporary art' testifies to this. What is attacked or defended under its name is by no means a common tendency that would serve to character-

*. Foucault's term: various institutional or admin. mechanisms & structures which maintains & endurance power within social body.

Aesthetics as Politics 23

ize the various arts of today. Of all the arguments put forward with respect to it, virtually no references are made to music, literature, cinema, dance or photography. Almost all of them bear instead on an object definable as that which succeeds to the place of painting, i.e. the arrangements of objects, the photographs, the video apparatuses, the computers – and sometimes even the performances – that occupy the spaces on whose walls portraits were previously to be seen. It would be wrong, however, to criticize these arguments for their 'partiality'. Indeed, 'art' is not the common concept that unifies the different arts. It is the *dispositif* that renders them visible. And 'painting' is not merely the name of an art. It is the name of a system of presentation of a form of art's visibility. Properly speaking, 'contemporary art' is a name for that *dispositif* which has taken the same place and function.

What the term 'art' designates in its singularity is the framing of a space of presentation by which the things of art are identified as such. And what links the practice of art to the question of the common is the constitution, at once material and symbolic, of a specific space–time, of a suspension with respect to the ordinary forms of sensory experience. Art is not, in the first instance, political because of the messages and sentiments it conveys concerning the state of the world. Neither is it political because of the manner in which it might choose to represent society's structures, or social groups, their conflicts or identities. It is political because of the very distance it takes with respect to these functions, because of the type of space and time that it institutes, and the manner in which it frames this time and peoples this space. Indeed, the figure I referred to above today suggests two sorts of transformation of this political function. In the aesthetics of the sublime, the space–time of a passive encounter with 'the heterogeneous' sets up a conflict between two different regimes of sensibility. In 'relational' art, the construction of an undecided and ephemeral situation enjoins a displacement of

perception, a passage from the status of spectator to that
of actor, and a reconfiguration of places. In both cases, the
specificity of art consists in bringing about a reframing of
material and symbolic space. And it is in this way that art
bears upon politics.

Politics, indeed, is not the exercise of, or struggle for,
power. It is the configuration of a specific space, the
framing of a particular sphere of experience, of objects
posited as common and as pertaining to a common deci-
sion, of subjects recognized as capable of designating these
objects and putting forward arguments about them.
Elsewhere, I have tried to show the sense in which politics
is the very conflict over the existence of that space, over
the designation of objects as pertaining to the common and
of subjects as having the capacity of a common speech.
Man, said Aristotle, is political because he possesses
speech, a capacity to place the just and the unjust in
common, whereas all the animal has is a voice to signal
pleasure and pain. But the whole question, then, is to
know who possesses speech and who merely possesses
voice. For all time, the refusal to consider certain catego-
ries of people as political beings has proceeded by means
of a refusal to hear the words exiting their mouths as dis-
course. The other way consists in the simple observation
of their material incapacity to occupy the space-time of
political things – as Plato put it, artisans have time for
nothing but their work. Of course this 'nothing', which
they have no time to do, is to be at the people's assembly.
Their 'absence of time' is actually a naturalized prohibition
written into the very forms of sensory experience.

Politics occurs when those who 'have no' time take the
time necessary to front up as inhabitants of a common
space and demonstrate that their mouths really do emit
speech capable of making pronouncements on the common
which cannot be reduced to voices signalling pain. This
distribution and redistribution of places and identities, this
apportioning and reapportioning of spaces and times, of
the visible and the invisible, and of noise and speech con-

stitutes what I call the distribution of the sensible.[10] Politics consists in reconfiguring the distribution of the sensible which defines the common of a community, to introduce into it new subjects and objects, to render visible what had not been, and to make heard as speakers those who had been perceived as mere noisy animals. This work involved in creating dissensus informs an aesthetics of politics that operates at a complete remove from the forms of staging power and mass mobilization which Benjamin referred to as the 'aestheticization of politics'.

More precisely, then, the relationship between aesthetics and politics consists in the relationship between this aesthetics of politics and the 'politics of aesthetics' – in other words in the way in which the practices and forms of visibility of art themselves intervene in the distribution of the sensible and its reconfiguration, in which they distribute spaces and times, subjects and objects, the common and the singular. Utopia or otherwise, the task that the philosopher attributes to the 'sublime' painting of the abstract painter, hung in isolation on a white wall, or that which the exhibition curator gives to the installation or intervention of the relational artist, both register the same logic: that of a 'politics' of art which consists in suspending the normal coordinates of sensory experience. One valorizes the solitude of a heterogeneous sensible form, the other the gesture that draws a common space. But these two different ways of relating the constitution of a material form and that of a symbolic space are perhaps two strands of the same originary configuration, namely that which links the specificity of art to a certain way of being of the community.

This means that art and politics do not constitute two permanent, separate realities whereby the issue is to know whether or not they *ought* to be set in relation. They are

[10] J. Rancière, *The Politics of Aesthetics: Distribution of the Sensible*, trans. and with intro. by Gabriel Rockhill, London and New York: Continuum, 2004 (French original, 2000).

two forms of distribution of the sensible, both of which are dependent on a specific regime of identification. There are not always occurrences of politics, although there always exist forms of power. Similarly, there are not always occurrences of art, although there are always forms of poetry, painting, sculpture, music, theatre and dance. That art and politics are perfectly conditional in character is shown in Plato's *Republic*. The famous exclusion of poets is often interpreted as the mark of a political pro-scription of art. However, the Platonic gesture also proscribes politics. One and the same distribution of the sensible both excludes artisans from the political scene where they might do *something other* than their work *and* prohibits poets from getting on the artistic stage where they might assume a character *other* than their own. Theatre and assembly: these are two interdependent forms of the same distribution, two spaces of heterogeneity that Plato was obliged to repudiate at the same time in order to constitute his Republic as the organic life of the community.

Art and politics are thereby linked, beneath themselves, as forms of presence of singular bodies in a specific space and time. Plato simultaneously excludes both democracy and theatre so that he can construct an ethical community, a community without politics. Today's debates about what ought to occupy museum space perhaps reveal a further form of solidarity between modern democracy and the existence of a specific space: that is, no longer the gather-ing of crowds around theatrical action, but instead the silent space of the museum in which the solitude and the passivity of passers-by encounter the solitude and passivity of artworks. Art's situation today might actually constitute one specific form of a much more general relationship that exists between the autonomy of the spaces reserved for art and its apparent contrary: art's involvement in constituting forms of common life.

In order to understand this apparent paradox, in which the politicity of art is tied to its very autonomy, it pays to

take a quick trip back in time to one of the first formula-
tions of the politics inherent to the aesthetic regime of art.
At the end of the fifteenth of his letters published as *Über
die ästhetische Erziehung des Menschen* in 1795, Schiller
invented an exhibition scenario which allegorizes a par-
ticular status of art and its politics.[11] He sets us in imagina-
tion before a Greek statue known as the *Juno Ludovisi*.
This statue, he says, is a 'free appearance'; it is self-
contained. To a modern ear this expression tends to evoke
the *self-containment* celebrated by Clement Greenberg.
But Schiller's 'self-containment' proves to be somewhat
more complicated than the modernist paradigm, which
seeks to emphasize the work's material autonomy. At issue
here is not to affirm the artist's unlimited power of crea-
tion, nor to demonstrate the powers specific to a particular
medium. Or instead: the *medium* at issue is not the matter
on which the artist works. It is a sensible milieu, a particu-
lar sensorium, foreign to the ordinary forms of sensory
experience. But this sensorium is identical neither with the
eucharistic presence of the *voici* nor with the sublime flash
of the Other. What the 'free appearance' of the Greek
statue manifests is the essential characteristic of divinity,
its 'idleness' or 'indifference'. The specific attribute of
divinity is not to want anything, to be liberated from the
concern to give oneself ends and to have to realize them.
And the artistic specificity of the statue inheres in its par-
ticipation in that 'idleness', in this absence of volition.
Standing before the idle goddess, the spectator is, too, in
a state that Schiller defines as that of 'free play'. — Diana Eck - Darshan.

While 'free appearance' tends at first to evoke the auton-
omy dear to modernism, 'free play' is at first more flattering
to postmodern ears. We know the place that the concept of
play occupies in the propositions and justifications of con-
temporary art. It figures as a way to distance oneself from

[11] Friedrich von Schiller, *Letters on the Aesthetic Education of Man*,
trans. Elizabeth M. Wilkinson and L.A. Willoughby, Oxford: Clarendon
Press, 1967 (German original, 1795).

modernist belief in the radicality of art and in its powers to tranform the world. The ludic and the humorous are, practically everywhere, credited as characterizing a kind of art presumed to have absorbed its contraries: on the one hand, the gratuitousness of amusement and critical distance; and, on the other, popular entertainment and the situationist *dérive*. Yet Schiller's staging could not place us at a greater distance from this disenchanted vision of play. Play is, Schiller tells us, the very humanity of man: 'Man is only fully a human being when he plays.'[11a] And he goes on to declare that this apparent paradox is 'capable of bearing the whole edifice of the art of the beautiful and of the still more difficult art of living'. How to understand that the 'gratuitous' activity of play can simultaneously found the autonomy of a specific domain of art *and* the construction of forms for a new collective life?

Let us begin at the beginning. To establish the edifice of art means to define a certain regime for the identification of art, that is to say a specific relationship between the practices, forms of visibility and modes of intelligibility that enable us to identify the products of these latter as belonging to art or to *an* art. One and the same statue of a goddess may or may not be art, or may be art differently depending on the regime in which it is apprehended. In the first place, there is a regime in which such a statue is exclusively apprehended as an *image* of divinity. Perceptions of it and the concomitant judgements thus get subsumed under questions such as: is it possible to form images of divinity?; is the depicted divinity a genuine divinity?; if so, is it depicted as it should be? In this regime, there is properly speaking no art as such but instead images that are judged in terms of their intrinsic truth and of their impact on the ways of being of individuals and of the collectivity. This is why I have proposed that this regime, in which art enters into a zone of indistinction, be referred to as an ethical regime of images.

[11a] Ibid., p. 107.

Next, there is a regime that frees the stone goddess from judgements about the validity of the divinity that is figured and the faithfulness of the depiction. This regime places statues of goddesses and stories of princes alike in a specific category, that of imitations. The *Juno Ludovisi*, then, becomes the product of an art, namely sculpture, a name which it merits for two reasons: first, because it imposes a form on a specific matter; and second, because it is the realization of a representation – the constitution of a plausible appearance that combines the imaginary traits of divinity with the archetypes of femininity, and the monumentality of the statue with the expressiveness of a particular goddess endowed with the traits of a specific character. The statue is a 'representation'. It is viewed through an entire grid of expressive conventions that determine the way in which the sculptor's skill in giving form to raw material is brought to coincide with the artistic capacity of rendering the appropriate figures according to the appropriate forms of expression. I call this regime of identification the representative regime of arts.

Schiller's *Juno Ludovisi* as well as Barnett Newman's *Vir Heroicus Sublimis* and the installations and perform- ances of relational art, belong to a different regime, which I call the aesthetic regime of art. In this regime, the statue of Juno does not draw its property of being an artwork from the conformity of the sculptor's work to an adequate idea or to the canons of representation. It draws it from its belonging to a specific sensorium. The property of being art refers back not to a distinction between the *sensorium.* modes of doing, but to a distinction between modes of being. This is what 'aesthetics' means: in the aesthetic regime of art, the property of being art is no longer given by the criteria of technical perfection but is ascribed to a specific form of sensory apprehension. The statue is a 'free appearance'. It stands thus in a twofold contrast to its representative status: it is not an appearance drawn from a reality that would serve as its model. Nor is it an active

form imposed on passive matter. As a sensory form, it is heterogeneous to the ordinary forms of sensory experience that these dualities inform. It is given in a specific experience, which suspends the ordinary connections not only between appearance and reality, but also between form and matter, activity and passivity, understanding and sensibility.

It is precisely this new form of distribution of the sensible that Schiller captures with the term 'play'. Minimally defined, play is any activity that has no end other than itself, that does not intend to gain any effective power over things or persons. This traditional sense of play was systematized in the Kantian analysis of aesthetic experience, which in effect is characterized by a twofold suspension: a suspension of the cognitive power of understanding that determines sensible givens in accordance with its categories; and a correlative suspension of the power of sensibility that requires an object of desire. The 'free play' of the faculties – intellectual and sensible – is not only an activity without goal; it is an activity that is equal to inactivity. From the outset, the 'suspension' that the player enacts, as compared with ordinary experience, is correlated to another suspension, namely the suspension of his own powers before the appearance of the 'idle' work, the work which, like the goddess, owes its unprecedented perfection to the fact that the will is withdrawn from its appearing. In sum, the 'player' stands and does nothing before the goddess, who herself does nothing, and the sculptor's work itself becomes absorbed within this circle of an inactive activity.

Why does this suspension simultaneously found a new art of living, a new form of 'life-in-common'? In other words, how does it happen that a certain 'politics' is consubstantial with the very definition of the specificity of art in this regime? The response, in its most general form, can be stated as follows: because it defines that which comes within the province of art through its adherence to a sensorium different to that of domination. In the Kantian

analysis, free play and free appearance suspend the power
of form over matter, of intelligence over sensibility. Schiller,
in the context of the French Revolution, translates these
Kantian philosophical propositions into anthropological
and political propositions. The power of 'form' over
'matter' is the power of the class of intelligence over the
class of sensation, of men of culture over men of nature.
If aesthetic 'play' and 'appearance' found a new commu-
nity, then this is because they stand for the refutation,
within the sensible, of this opposition between intelligent
form and sensible matter which, properly speaking, is a
difference between two humanities.

It is here that the notion according to which man is
fully human only when he plays takes on its meaning.
Play's freedom is contrasted to the servitude of work.
Symmetrically, free appearance is contrasted to the
constraint that relates appearance to a reality. These
categories – appearance, play, work – are the proper cat-
egories of the distribution of the sensible. What they in
fact describe are the forms of domination and of equality
operative within the very tissue of ordinary sensory experi-
ence. In the Platonic Republic, the mimetician is as much
deprived of the power of 'free appearance' as the artisan
is of the possibility to engage in free play. There exists no
appearance without a reality that serves to judge it, no
gratuity of play compatible with the seriousness of work.
These two prescriptions are strictly linked to each other
and together define a partition of the sensible that at once
excludes both art and politics, and makes way for the
direct ethical guidance of the community. More generally,
the legitimacy of domination has always rested on the
evidence of a sensory division between different humani-
ties. Earlier I quoted Voltaire's assertion that the common
people are deemed not to have the same sense as refined
people. The power of the elite here is thus the power
of educated senses over that of unrefined senses, of
activity over passivity, of intelligence over sensation.
The forms of sensory experience themselves were charged

with identifying differences in function and place with differences in nature.

What aesthetic free appearance and free play challenge is the distribution of the sensible that sees in the order of domination a difference between two humanities. Both notions manifest a freedom and an equality of sense [*sentir*] which, in 1795, stood in stark contrast to those that the French Revolution's 'reign of the Law' strived to embody. The reign of the Law, in effect, still amounts to the reign of free form over slavish matter, of the State over the masses. The Revolution turned to terror, in Schiller's view, because it still adhered to the model according to which an active intellectual faculty constrains passive sensible materiality. The aesthetic suspension of the supremacy of form over matter and of activity over passivity makes itself thus into the principle of a more profound revolution, a revolution of sensible existence itself and no longer only of the forms of State.

It is therefore as an autonomous form of experience that art concerns and infringes on the political division of the sensible. The aesthetic regime of art institutes the relation between the forms of identification of art and the forms of political community in such a way as to challenge in advance every opposition between autonomous art and heteronomous art, art for art's sake and art in the service of politics, museum art and street art. For aesthetic autonomy is not that autonomy of artistic 'making' celebrated by modernism. It is the autonomy of a form of sensory experience. And it is that experience which appears as the germ of a new humanity, of a new form of individual and collective life.

Thus there is no conflict between the purity of art and its politicization. The two centuries that separate us from Schiller testify to the contrary: it is by dint of its purity that the materiality of art has been able to make of itself the anticipated materiality of a different configuration of the community. If the creators of pure forms of so-called abstract painting were able to transform themselves into

the artisans of a new Soviet life, it is not by virtue of some circumstantial subordination to an extrinsic utopia. What the non-figurative purity of the canvas – its gaining of planarity over three-dimensional illusion – did not signify was what one has strived to make it signify: pictorial art's exclusive concentration on its material. It marked, on the contrary, the belonging of the new pictorial gesture to a surface/interface where pure art and applied art, functional art and symbolic art, merged, where the geometry of the ornament became the symbol of inner necessity and where the purity of the line became the constitutive instrument for a new décor for living [la vie], itself susceptible to being transformed into the décor of the new life. Even Mallarmé, the pure poet par excellence, assigned to poetry the task of organizing a different topography of common relations, of preparing the 'festivals of the future'.

There is no conflict between purity and politicization. But we must take care to understand what 'politicization' means. What aesthetic education and experience do not promise is to support the cause of political emancipation with forms of art. Their politics is a politics that is peculiar to them, a politics which opposes its own forms to those constructed by the dissensual interventions of political subjects. Such a 'politics', then, actually ought to be called a metapolitics. In general, metapolitics is the thinking which aims to overcome political dissensus by switching scene, by passing from the appearances of democracy and of the forms of the State to the infra-scene of underground movements and the concrete energies that comprise them. For more than a century, Marxism has represented the ultimate form of metapolitics, returning the appearances of politics to the truth of the productive forces and relations of production, and promising, instead of political revolutions that merely bring about a change in the form of State, a revolution in the very mode of production of material life. But in itself the revolution of producers is conceivable only after a revolution within the very idea of revolution, in the idea of a revolution of the forms of

sensible existence as opposed to a revolution of state forms. The revolution of producers is a particular form of aesthetic metapolitics.

There is no conflict between art's purity and this politics. But there is a conflict within purity itself, in the conception of this materiality of art which prefigures another configuration of the common. Mallarmé attests to this also: on the one hand, the poem has the consistency of a heterogeneous sensory block – it is a volume closed on itself, materially refuting the newspaper's 'unaltered' space and 'uniform casting of ink'; on the other, the poem has the inconsistency of a gesture which dissipates in the very act of instituting a common space, similar to a national holiday fireworks display. It is a ceremonial of the community, comparable with ancient theatre or the Christian mass. On the one hand, then, the collective life to come is enclosed in the resistant volume of the artwork; on the other, it is actualized in the evanescent movement which outlines a different common space.

If there is no contradiction between art for art's sake and political art, this is perhaps because the contradiction is lodged more deeply, in the very core of aesthetic experience and its 'education'. On this point, once again, Schiller's text clarifies the logic of an entire regime for identifying art and its politics, that which is conveyed today by the contrast between a sublime art of forms and a modest art of behaviours and of relations. The scenario in Schiller's work permits us to see how these two opposites are contained in the same initial kernel. On the one hand, indeed, free appearance is the power of a heterogeneous sensible element. The statue, like the divinity, holds itself opposite the – idle – subject, in other words it is foreign to all volition, to every combination of means and of ends. It is closed on itself, that is to say inaccessible for the thought, desires and ends of the subject contemplating it. And it is only by this strangeness, by this radical unavailability, that it bears the mark of man's full humanity and the promise of a humanity to come, one at last in tune with the fullness

of its essence. This statue, which the subject of aesthetic experience cannot in the least possess, promises the possession of a new world. And aesthetic education, as the compensation for political revolution, is the education received through the strangeness of free appearance, through the experience of non-possession and passivity that it imposes.

However, from another angle, the statue's autonomy pertains to the mode of life that is expressed in it. The attitude of the idle statue, its autonomy, is in effect a result: it is the expression of the comportment of the community whence it issues. It is free because it is the expression of a free community. Only, the meaning of this freedom is inverted: a free, autonomous community is a community whose lived experience is not divided into separate spheres, which has no experience of any separation between everyday life, art, politics and religion. In this logic, the Greek statue is art for us because it was not art for its author, because, in sculpting it, this author was not making an 'artwork' but translating into stone the shared belief of a community, identical with its very way of being. What the suspension of free appearance thus promises is a community that is free insofar as it, too, no longer experiences these separations, no longer experiences art as a separate sphere of life.

Hence, the statue carries political promise because it is the expression of a specific distribution of the sensible. But this distribution can be understood in two opposite ways, depending on how the experience is interpreted: on the one hand, the statue is a promise of community because it is art, because it is the object of a specific experience and thereby institutes a specific, separate common space; on the other, it is a promise of community because it is not art, because all that it expresses is a way of inhabiting a common space, a way of life which has no experience of separation into specific realms of experience. Aesthetic education is therefore the process that transforms the solitude of free appearance into lived reality and changes

aesthetic idleness into the action of a living community. The very structure of Schiller's *Über die ästhetische Erziehung des Menschen* testifies to this shift in rationalities. Where the first and second parts of his work insist on the appearance's autonomy and the necessity of protecting material 'passivity' from the undertakings of imperious understanding, the third, conversely, describes a process of civilization in which aesthetic enjoyment amounts to a domination of human volition over a matter that it contemplates as the reflection of its own activity.

The politics of art in the aesthetic regime of art, or rather its metapolitics, is determined by this founding paradox: in this regime, art is art insofar as it is also non-art, or is something other than art. We therefore have no need to contrive any pathetic ends for modernity or imagine that a joyous explosion of postmodernity has put an end to the great modernist adventure of art's autonomy or of emancipation through art. There is no postmodern rupture. There is a contradiction that is originary and unceasingly at work. The work's solitude carries a promise of emancipation. But the fulfilment of that promise amounts to the elimination of art as a separate reality, its transformation into a form of life.

On the basis of this fundamental nucleus, therefore, aesthetic 'education' splits into two figures, as witnessed in the sublime nudity of the abstract work championed by the philosopher and in the propositions for new and interactive types of relationship proposed by the artist and today's exhibition curator. On the one hand, there is a project for aesthetic revolution in which art, by effacing its difference as art, becomes a form of life. On the other, there is the resistant figure of the work in which political promise is negatively preserved, not only through the separation between artistic form and other forms of life, but also through the inner contradiction of this form itself.

The scenario depicted by aesthetic revolution is one that proposes to transform aesthetics' suspension of the relations of domination into the generative principle for a

world without domination. This proposition entails an opposition between two types of revolution: against political revolution *qua* revolution of State in which the separation between two humanities is *de facto* renewed, it asserts revolution *qua* formation of a community of sense [*sentir*]. This succinct formula sums up the famous text written together by Hegel, Schelling and Hölderlin, namely *Das älteste Systemprogramm des Deutschen Idealismus*.[11b] In this programme a contrast is made between the dead mechanism of state and the living power of the community nourished by the sensible embodiment of its idea. This opposition between death and life is too simple and in fact enacts a twofold elimination. On the one hand, it causes the 'aesthetics' of politics to vanish, i.e. the practice of political dissensuality, promulgating in its stead the formation of a 'consensual' community, not a community in which everyone is in agreement, but one that is realized as a community of feeling. But for this to occur, 'free appearance' must be transformed into its contrary, that is the activity of a conquering human mind that eliminates the autonomy of aesthetic experience, transforming all sensible appearance into the manifestation of its own autonomy. The task of 'aesthetic education' advocated by *Das älteste Systemprogramm* is to render ideas sensible, to turn them into a replacement for ancient mythology; in other words, into a living tissue of experiences and common beliefs in which both the elite and the people share. The 'aesthetic' programme, therefore, is essentially a metapolitics, which proposes to carry out, in truth and in the sensible order, a task that politics can only ever accomplish in the order of appearance and form.

We know: not only did this programme define an idea of aesthetic revolution but also an idea of revolution *tout court*. Without having had the chance to read that

[11b] Hegel, Schelling and Hölderlin, *The Oldest of Systematic Program of German Idealism*, ed. Ernst Behler, London and New York: Continuum, 1987 (German original, 1797).

forgotten draft, Marx came, half a century later, to trans-
pose it precisely into the scenario of a revolution that is
no longer political but human, a revolution that, once
more, is supposed to realize philosophy by eliminating it
and giving to man the possession of that which he had
formerly only ever had the appearance. By the same token,
what Marx proposed was a new and enduring identifica-
tion of aesthetic man: namely, productive man, the one
who at once produces both the objects and the social rela-
tionships in which they are produced. This identification
formed the basis on which a juncture emerged between the
Marxist vanguard and the artistic avant-garde in the
1920s, since each side adhered to the same programme:
the joint elimination of political dissensuality and aesthetic
heterogeneity in the construction of forms of life and of
edifices for the new life.

It is nevertheless too simple to reduce this figure of aes-
thetic revolution to 'utopian' and 'totalitarian' catastro-
phe. The project of 'art become life' is not limited to the
programme of the 'elimination' of art, announced some
time ago by constructivist engineers and the suprematist
or futurist artists of the Soviet revolution. It is consubstan-
tial with the aesthetic regime of art. It already inspired, in
their dreams of the artisanal and communitarian Middle
Ages, the artists of the Arts and Crafts movement. It was
taken up again by the artisans of the Art Deco movement,
hailed in their time as producers of 'social art',[12] as it was
by the engineers and architects of the Werkbund and the
Bauhaus, before again flowering into the utopian projects
of situationist urbanists and Joseph Beuys' 'social plastic'.
But it also haunts those Symbolist artists reputed to
be as far from revolutionary projects as is possible.
Notwithstanding their differences, the 'pure' poet Mallarmé
and the engineers of the Werkbund share the idea of an
art which, by suppressing its singularity, is able to produce
the concrete forms of a community that has finally dis-

[12] Roger Marx, *L'Art social*, Paris: Eugène Fasquelle, 1913.

pensed with the appearances of democratic formalism.[13]
Here, there is no chant coming from totalitarian sirens,
but simply the manifestation of a contradiction, that per-
taining to the metapolitics rooted in the very status of the
aesthetic work itself, in the original knot it implies between
the singularity of the 'idle' appearance and the act that
transforms appearance into reality. Aesthetic metapolitics
cannot fulfil the promise of living truth that it finds in
aesthetic suspension except at the price of revoking this
suspension, that is of transforming the form into a form
of life. In this regard, we might think of the contrast made
by Malevich in 1918 between Soviet construction and
museum works. We might think of the endeavour to design
integrated spaces in which painting and sculpture are no
longer manifest as separate objects but directly projected
into life, thus eliminating art as 'something that is distinct
from our surrounding milieu, which is the veritable plastic
reality'.[14] Or again we might think of the urban *dérive* and
type of play that Guy Debord brought to bear against the
totality of Capitalist or Soviet life, alienated in the form
of the king-spectacle.[14a] In all these cases, the politics of
the free form demands that the work realize itself, that it
eliminate itself in act, that it eliminate the sensible hetero-
geneity which founds aesthetic promise.

The other great form of 'politics' specific to the aesthetic
regime of art is precisely the one that refuses an elimina-
tion of form in act, namely the politics of the resistant
form. In such a politics, form asserts its politicity by dis-
tinguishing itself from every form of intervention into the

[13] Concerning this convergence, I refer to my essay 'The Surface of
Design', in *The Future of the Image*, London: Verso, 2007 (French
original, 2003).
[14] Piet Mondrian, 'L'art plastique et l'art plastique pur', in Charks
Harrison and Paul Wood, eds., *Art en théorie, 1900–1990*, Paris:
Hazan, 1997, p. 420.
[14a] Guy Debord, *The Society of the Spectacle*, trans. Donald Nicholson-
Smith, New York: Zone Books, 1999 (French original, 1967); a film
version was produced in 1973.

mundane world. Art does not have to become a form of
life. On the contrary, it is in art that life takes its form.
The Schillerian goddess carries promise because she is
'idle'. 'The social function of Art', as Adorno will echo, 'is
to not have one.' Egalitarian promise is enclosed in the
work's self-sufficiency, in its indifference to every particu-
lar political project and in its refusal to get involved in
decorating the mundane world. It is owing to this indiffer-
ence that, in the middle of the nineteenth century, that
work about nothing, that work 'supported on itself' written
by the aesthete Flaubert, was straightaway perceived
by the contemporary advocates of the hierarchical order
as a manifestation of 'democracy'. The work that desires
nothing, the work without any point of view, which
conveys no message and has no care either for democracy
or for anti-democracy, this work is 'egalitarian' by dint of
its very indifference, by which it suspends all preference,
all hierarchy. It is subversive, as subsequent generations
would discover, by dint of its radical separation of the
sensorium of art from that of everyday aestheticized life.
A contrast is thereby formed between a type of art that
makes politics by eliminating itself as art and a type of art
that is political on the proviso that it retains its purity,
avoiding all forms of political intervention.

It is this form of politicity, tied to the work's very indif-
ference, that a whole political avant-gardist tradition came
to internalize. The tradition strove to bring together politi-
cal avant-gardism and artististic avant-gardism by their
very distance. Its programme is encapsulated in a rallying
cry: protect the heterogeneity of the sensible that forms the
core of art's autonomy and *therefore* constitutes its poten-
tial for emancipation. Save it from a twofold threat: from
its transformation into a metapolitical act and from its
assimilation into the forms of aestheticized life. It is this
demand that is encapsulated in Adorno's aesthetics. The
work's political potential is associated with its radical
separation from the forms of aestheticized commodities
and of the administered world. But this potential does not

reside in the simple solitude of the work, no more than it does in the radicality of artistic self-affirmation. The purity that this solitude authorizes is the purity of internal contradiction, of the dissonance by which the work testifies to the non-reconciled world. The autonomy of the Schoenbergian work, as conceptualized by Adorno, is in fact a twofold heteronomy: in order to denounce the capitalist division of work and the embellishments of commodities effectively, the work has to be even more mechanical, more 'inhuman' than the products of mass capitalist consumption. But, in its turn, this inhumanity causes the stain of the repressed to appear, thus disturbing the autonomous work's beautiful technical arrangement by recalling that which founds it: the capitalist separation of work and enjoyment.

In this logic, the promise of emancipation is retained, but the cost of doing so entails refusing every form of reconciliation, or maintaining the gap between the dissensual form of the work and the forms of ordinary experience. This vision of the work's politicity brings with it a heavy consequence. It commands that aesthetic difference, guardian of the promise, be established in the sensorial texture of the work itself; and thereby it in a way reconstitutes the Voltairean opposition between two forms of sensibility. The diminished-seventh chords that enchanted the salons of the nineteenth century *can* no longer be heard, said Adorno, 'unless everything is deception.'[15] If our ears can still listen to them with pleasure, the aesthetic promise, the promise of emancipation, is proved a lie.

One day, however, we really must face up to the obvious fact that we can still hear them. And, similarly, we *can* see figurative and abstract motifs mixed on the same canvas, or make art by borrowing and re-exhibiting objects from

[15] Theodor Adorno, *Philosophy of New Music*, trans. Robert Hullot-Kentor, Minneapolis: University of Minnesota Press, 2006 (German original, 1949).

ordinary life. Some would like to see in this the mark of a radical rupture whose proper name is postmodernity. But the notions of modernity and postmodernity misguidedly project, in the form of temporal succession, antagonistic elements whose tension infuses and animates the aesthetic regime of art in its entirety. This regime has always lived off the tension between contraries. The autonomy of aesthetic experience, which founds the idea of Art *qua* autonomous reality, is here accompanied by the elimination of all pragmatic criteria for extricating the domain of art from that of non-art, the solitude of the work from the forms of collective life. There is no postmodern rupture. But there is a dialectic of the 'apolitically political' work. And there is a limit at which its very project cancels itself out.

It is this limit of the autonomous/heteronomous work, political thanks to its very detachment from political will, to which the Lyotardian aesthetic of the sublime testifies. The task assigned to the artistic avant-garde still involves tracing a perceptible boundary that sets artworks apart from the products of commercial culture. But the very sense of this tracing is inverted. What the artist inscribes is no longer the promise-carrying contradiction, the contradiction of labour and enjoyment. The artist inscribes the shock of the *aistheton*, attesting to the mind's alienation from the power of an irremediable alterity. The work's sensible heterogeneity no longer vouches for the promise of emancipation. On the contrary, it comes to invalidate every such promise by testifying to the mind's irremediable dependency with regard to the Other inhabiting it. The work's enigma, which inscribed the contradiction of a world, becomes the pure testimony of the power of that Other.

Hence, the metapolitics of the resistant form tends to oscillate between two positions. On the one hand, it assimilates this resistance with the struggle to preserve the material difference of art apart from all the worldly affairs that compromise it: the commerce of mass exhibitions and

cultural products by which it becomes a profit-making industrial enterprise; the pedagogy aiming to bring art closer to the social groups to whom it is foreign; and attempts to integrate art into a 'culture', further divided into various social, ethnic or sexual group cultures. Art thus takes up a combat against culture, instituting a frontline on one and the same side of which stand the defence of the 'world' against 'society', of works against cultural products, of things against images, of images against signs and of signs against simulacra. This denunciation can easily be incorporated into political attitudes that demand to re-establish a republican-style education to counter the democratic dissolution of forms of knowledge, behaviours and values. And it passes an overall negative judgement on contemporary restlessness, preoccupied with blurring the boundaries between art and life, signs and things.

But, at the same time, this jealously guarded art tends to become a mere testimony to the power of the Other and the risk of catastrophe continuously run by forgetting it. The trailblazers of the avant-garde become the sentinel that watches over the victims and keeps the memory of catastrophe alive. Here again, the politics of the resistant form accomplishes itself at the exact moment that it is cancelled out. It does so, no longer as part of a metapolitics of revolution of the sensory world, but by identifying the work of art with the ethical task of bearing witness, cancelling out, once again, both art and politics. This ethical dissolution of aesthetic heterogeneity goes hand-in-hand with a whole current of contemporary thought in which political dissensuality is dissolved into an archipolitics of the exception and in which all forms of domination, or of emancipation, are reduced to the global nature of an ontological catastrophe from which only a God can save us.

What we must therefore recognize both in the linear scenario of modernity and postmodernity, and in the academic opposition between art for art's sake and engaged art, is an originary and persistent tension between the two

great politics of aesthetics: the politics of the becoming-life of art and the politics of the resistant form. The first identifies the forms of aesthetic experience with the forms of an other life. The finality it ascribes to art is to construct new forms of life in common, and hence to eliminate itself as a separate reality. The second, by contrast, encloses the political promise of aesthetic experience in art's very separation, in the resistance of its form to every transformation into a form of life.

This tension does not result from any unfortunate compromises art may have made with politics. These two 'politics' are in effect implicated in the same forms by which we identify art as the object of a specific experience. From this, however, it is by no means necessary to conclude that there has been a disastrous captation of art by 'aesthetics'. To repeat, there is no art without a specific form of visibility and discursivity which identifies it as such. There is no art without a specific distribution of the sensible tying it to a certain form of politics. Aesthetics is such a distribution. The tension between these two politics threatens the aesthetic regime of art. But it is also what makes it function. Isolating these opposed logics, and the extreme point at which both of them are eliminated, by no means obliges us to announce the end of aesthetics as others have the end of politics, of history or of utopias. But it can help us to understand the paradoxical constraints that weigh on the project, so apparently simple, of 'critical art', a project which arranges, in the form of the work, either an explanation of domination or a comparison between what the world is and what it might be.[16]

[16] This chapter and the following one were both developed thanks to a seminar on *Aesthetics and Politics* held in May 2002 in Barcelona under the auspices of the Museu d'Art Contemporani. They are also indebted to a seminar held on the same subject in June 2001 at the *School for Criticism and Theory*, Cornell University, Ithaca, New York.

Problems and
Transformations of Critical Art

In its most general expression, critical art is a type of art that sets out to build awareness of the mechanisms of domination to turn the spectator into a conscious agent of world transformation. The quandary that plagues the project is well known. On the one hand, understanding does not, in and of itself, help to transform intellectual attitudes and situations. The exploited rarely require an explanation of the laws of exploitation. The dominated do not remain in subordination because they misunderstand the existing state of affairs but because they lack confidence in their capacity to transform it. Now, the feeling of such a capacity presupposes that the dominated are already committed to a political process in a bid to change the configuration of sensory givens and to construct forms of a world to come, from within the existent world. On the other hand, the work which builds understanding and dissolves appearances kills, by so doing, the strangeness of the resistant appearance that attests to the non-necessary or intolerable character of a world. Insofar as it asks viewers to discover the signs of Capital behind everyday objects and behaviours, critical art risks being inscribed in the perepetuity of a world in which the transformation of things into signs is redoubled by the very excess of

interpretative signs which brings things to lose their capacity of resistance.

Critical art's vicious circle is generally seen as proof that aesthetics and politics cannot go together. It would be more valid to see in it the plurality of ways in which they are linked. On the one hand, politics is not the simple sphere of action that follows an 'aesthetic' revelation about the state of things. It has its own specific aesthetics: in other words, it has its own modes of dissensual invention of scenes and of characters, of demonstrations and statements, which distinguish it from, and sometimes even oppose it to, the inventions of art. On the other, aesthetics itself has its own specific politics, or rather it contains a tension between two opposed types of politics: between the logic of art becoming life at the price of its self-elimination and the logic of art's getting involved in politics on the express condition of not having anything to do with it. The difficulty of critical art does not reside in its having to negotiate the relationship between politics and art. It resides in its having to negotiate the relationship between two aesthetic logics that, insofar as they belong to the very logic of the aesthetic regime, exist independently of it. Critical art has to negotiate between the tension which pushes art towards 'life' as well as that which, conversely, sets aesthetic sensorality apart from the other forms of sensory experience. It has to borrow the connections that foster political intelligibility from the zones of indistinction between art and the other spheres. And from the solitude of the work it has to borrow the sense of a sensible heterogeneity which feeds political energies of refusal. It is this negotiation between the forms of art and those of non-art which makes it possible to form combinations of elements capable of speaking twice over: on the basis of their legibility and on the basis of their illegibility.

Combining these two powers, then, necessarily involves adjusting heterogeneous logics. If collage has been one

of modern art's major techniques, the reason is that its technical forms obey a more fundamental aesthetico-political logic. Collage, in the broadest sense of the term, is the principle of a 'third' political aesthetics. Before combining paintings, newspapers, oilcloths or clock-making mechanisms, it combines the foreignness of aesthetic experience with the becoming-art of ordinary life. Collage can be realized as the pure encounter between heterogeneous elements, attesting *en bloc* to the incompatibility of two worlds. The Surrealist encounter between the umbrella and the sewing-machine, for example, manifests – in contrast to the reality of ordinary everyday life but in accord with its objects – the absolute power of desire and dream. Conversely, collage can present itself as that which brings to light the hidden link between two apparently foreign worlds, as can be seen in the photomontage by John Heartfield titled *Adolf, the Superman, Swallows Gold and Spouts Tin*, which reveals the reality of capitalist gold in Hitler's throat, or in Martha Rosler's *Bringing the War Home: House Beautiful*, in which photos of the horrors of the Vietnam War are combined with advertisements of American comfort. The issue here is no longer to present two heterogeneous worlds and to incite feelings of intolerability, but, on the contrary, to bring to light the causal connection linking them together.

But the politics of collage has a balancing-point in that it can combine the two relations and play on the line of indiscernibility between the force of sense's legibility and the force of non-sense's strangeness. This is so, for example, in the stories about cauliflowers in Brecht's *Arturo Ui*, in which an exemplary double game is played between denunciations of commodity rule and the forms of high art's derision that came with the commercialization of culture. They play at once on the ability to discern the power of capital beneath an allegory of Nazi power and on the buffoonery that reduces every grand ideal, political or

otherwise, to some insignificant story of vegetables.[16a] The secret of the commodity to be read beneath great discourses is equal to its absence of secret, to its triviality or radical non-sensicality. But this possibility of playing at the same time on sense and non-sense also presupposes that one can play simultaneously on the radical separation between the art world and that of cauliflowers *and* on the permeability of the border that separates them. This requires both that cauliflowers bear no relation to art or politics and that they are already linked to them, that the border is always there and nevertheless already crossed.

In fact, by the time that Brecht employed them for the purposes of critical distantiation vegetables had already had a long artistic history. We might recall their role in Impressionist still-life painting. We might also think of the way in which Zola's novel *Le Ventre de Paris* (1873) elevates vegetables in general – and cabbages in particular – to the dignity of artistic and political symbols. This work, written just after the Paris Commune's crushing, is in effect constructed around a polarity between two characters: on the one hand, the revolutionary who returns after deportation to the new Paris des Halles and finds himself overwhelmed by masses of commodities, which materialize the new world of mass consumption; on the other, the Impressionist painter who celebrates the epic saga of cabbages, of the new beauty, contrasting the iron architecture of les Halles (the central markets) and the piles of vegetables it houses with the old henceforth private beauty of life, symbolized by the neighbouring Gothic church.

This twofold Brechtian play on the politicity and a-politicity of cauliflowers is possible because there already exists a relationship between politics, the new style of

[16a] Brecht's play *The Resistible Rise of Arturo Ui* (German original, 1941) is a parable on the rise of Hitler and the complacency of those who enabled it to happen. The play is set in the gangsterland of 1930s Chicago in the midst of economic turmoil and presents Arturo in his bid to gain control of the Cauliflower Trust (the representative of German Capitalism and the Junker Class).

beauty and commodity displays. We can generalize the sense of this history of vegetables. Critical art, as art which plays both on the union and the tension of aesthetic politics, is possible thanks to the movement of translation which, for quite some time already, had crossed back and forth over the line separating the specific world of art and the prosaic world of commodities. There is no need to imagine that a 'postmodern' rupture emerged, blurring the boundaries between great art and the forms of popular culture. This blurring of boundaries is as old as 'modernity' itself. Brechtian distantiation[16b] is obviously indebted to the Surrealist collages that introduce into the domain of art the obsolete merchandise of Parisian passages or magazine illustrations or *démodé* catalogues. But the process extends much further back. The time when great art was constituted – and, with Hegel, declared as its own end – is the same time when it began to become commonplace in magazine productions and corrupted in bookstore trade and the newspaper – or so-called industrial literature. Once again, however, it was at this same time that commodities started travelling in the opposite direction, crossing the border separating them from the world of art, in order to replenish and rematerialize the very art whose forms Hegel considered to have been exhausted.

This is exactly what Balzac demonstrates in the cycle of novels *Illusions perdues* (1837–43). The muddy and dilapidated stalls of the Galeries de Bois, where the deposed poet, Lucien de Rubempré, goes to sell his prose and soul, surrounded by stock exchange deals and prostitution, turns at once into the site of a new poetry: a fantastical poetry born of the abolition of borders between the ordinariness of commodities and the extraordinariness of art. The sensory

[16b] Translator's note: 'distantiation' is my term for *distanciation*, the common translation into French of Brecht's neologism *Verfremdungseffekt*. The subtleties of the original German are perhaps best captured by the more literal 'estrangement effect', but I have chosen 'distantiation' to fit the context of Rancière's discussion.

heterogeneity on which art feeds in the aesthetic age can be found anywhere at all and most especially on the very terrain from which the purists want to divert it. For by becoming obsolete, unfit for consumption, any old commodity, any object of use whatsoever, becomes available for art, and in diverse ways that can be separated or conjoined: as a disinterested object of satisfaction, as a body ciphering a story, or as a witness to an inassimilable strangeness.

Whereas some people devoted art-life to the creation of furniture for the new life, and some denounced the transforming of art products into aestheticized commodities, there were others who took note of this double movement blurring the basic opposition between the two great politics of aesthetics: if art's products unceasingly cross over into the domain of commodities, conversely commodities and usable objects do not cease to cross the border in the opposite direction, to leave the sphere of usefulness and value behind; they then become either hieroglyphs bearing their history on their bodies or disused, silent objects bearing the splendour of that which no longer supports any project, any will. It is in this way that the 'idleness' of *Juno Ludovisi* was to communicate itself to any obsolete object of use or publicity icon. This 'dialectical work within things', which renders them available to art and subversion by breaking the uniform course of time, by putting back one time in another, by changing the status of objects and the relationship between signs of exchange and the forms of art, is the illumination Walter Benjamin had in reading Aragon's *Paysan de Paris*, wherein the obsolete walking-stick store in the Passage de l'Opéra is transformed into a mythological landscape and a fantastical poem. And the 'allegorical' art to which so many contemporary artists claim to adhere is inscribed in this long-standing filiation.

It is by this crossing over of borders and changes of status between art and non-art that the radical strangeness of the aesthetic object and the active appropriation of the common world were able to conjoin and that a 'third way' micro-politics of art was able to take shape between the

contrasting paradigms of art as life and as resistant form. This is the process which has nourished the performances of critical art and which can help us to understand its contemporary transformations and ambiguities. If there is a political question in contemporary art, it will not be grasped in terms of a modern/postmodern opposition. It will be grasped through an analysis of the metamorphoses of the political 'third', the politics founded on the play of exchanges and displacements between the art world and that of non-art.

From Dadaism through to the diverse kinds of 1960s contestatory art, the politics of mixing heterogeneous elements had one dominant form: the polemical. Here, the play of exchanges between art and non-art served to generate clashes between heterogeneous elements and dialectical oppositions between form and content, which themselves served to denounce social relations and the place reserved for art within them. Brecht gave a stichomythic form to a discussion in verse on the affairs of cauliflowers so as to denounce the interests concealed behind big words. Dadaist canvases had bus tickets, clock springs and other such items stuck on them as a way of ridiculing art's pretensions to separate itself from life. Warhol's introduction of soup tins and Brillo soap boxes into the museum worked to denounce great art's claims to seclusion. To name only three further examples: Wolf Vostell's mixing of images of stars together with images of war revealed the grim side of the American dream; Krzysztof Wodiczko's projections of homeless figures onto American monuments pointed to the expulsion of the poor from public space; and Hans Haacke's act of sticking small plaques onto museum works pointed up their nature as objects of speculation. The collage of heterogeneous elements generally took the form of a shock, revealing one world hidden beneath another: capitalist violence beneath the happiness of consumption; and commercial interests and violence of class struggle beneath the serene appearances of art. In this way, art's self-critique became involved in the critique of mechanisms of state and market domination.

The polemical function, produced by the shock of heterogeneous elements, is still the order of the day when it comes to legitimizing works, installations and exhibitions. Nevertheless, this discursive continuity covers over a significant transformation which a single example shall suffice to grasp. In 2000, in Paris, an exhibition entitled *Bruit de fond* placed works from the 1970s and contemporary works opposite one another, some of them sound installations, hence the title's allusion to white noise. Figuring among the former were photomontages from Martha Rosler's series *Bringing the War Home: House Beautiful.* Hung on the wall close by was a sculptural collage by Wang Du, also devoted to the hidden face of American happiness:[16c] on the left, Bill and Hillary Clinton are shown as figures from a wax museum; on the right, the artist depicts another sort of wax figure, a plastification of Courbet's *L'Origine du monde*, which, as is well known, is a close-up representation of female sex organs. Both works also played on the relation between an image of happiness or of greatness and the concealed face of its violence or profanity. But the Clinton couple could not be invested with a political stake by the mere relevance of the Lewinsky affair. Precisely, the news was hardly important. All it presented to us was the automatic functioning of the canonical procedures of delegitimization: the wax figure that turns the politician into a puppet; the sexual profanity that is the dirty little hidden/obvious secret underlying every form of sublimity. These procedures still work. But they work by turning in on themselves, just like deriding power in general has taken the place of political denunciation. Or else their function is to make us sensitive to this automaticity itself, to delegitimize the procedures of delegitimization at the same time as their object. Thereby does humorous distantiation take the place of the provocative shock.

[16c] Wang Du, *Les Temps du monde* (1988).

I chose the significant example of Wang Du's work, but many others could be cited as proof of the same shift from yesterday's dialectical provocations to the new figures of the composition of heterogeneous elements under the apparent continuity of artistic *dispositifs* and their textual legitimizations. More, it seems possible to classify these multiple shifts into four major figures of the contemporary exhibition: the play, the inventory, the encounter and the mystery.

First the play [*jeu*], that is to say the double play. I have evoked elsewhere the exhibition presented in Minneapolis under the title *Let's Entertain* and rebaptized in Paris as *Au-delà du spectacle*.[17] A double game was already at work in the American title, with a wink to intimate its denunciation of the entertainment industry and a pop-style denunciation of the division between great art and popular consumption culture. The Parisian title introduced an extra twist. On the one hand, its reference to Debord's book (noted above) reinforced its rigorism concerning the critique of entertainment; but, on the other, it recalled that in Debord's work the antidote to the passivity of the spectacle is the free activity of play. This play on titles of course was also a reference to the undecidability of the status of the works themselves. Charles Ray's merry-go-round and Maurizio Cattelan's giant baby foot were equally open to being symbolized either as pop derision, the critique of commercial entertainment, or the positive power of play. It required all the conviction of the exhibition's curators to make clear that the mangas, publicity films and disco sounds reprocessed by various authors, provided us, by their very reduplication, with a radical critique of the alienated consumption of leisure activities. Instead of the Schillerian suspension of relations of domination, the play invoked here marks the suspension of the signification of the collages on display. The value of their polemical revelation

[17] Rancière, *The Future of the Image*, trans. Gregory Elliott, London and New York: Verso, 2007, p. 25 (French original, 2003).

has become undecidable. And it is the production of this undecidability that is at the core of the work of many artists and expositions. Where the critical artist depicted the lurid icons of commercial domination or imperialist war, the video artist slightly deflects [*détournes*] video-clips and mangas. Where giant marionettes were once used to present contemporary history as epic spectacle, today balloons and soft toys 'inquire into' our lifestyles. A slightly deflected reduplication of spectacles, accessories and icons of everyday life no longer invites us to read signs on objects in order to understand the mechanisms of our world. It claims at once to sharpen our perception of the interplay of signs, our awareness of the fragility of the procedures of reading these same signs, and our pleasure in playing with the undecidable. Humour is the virtue to which artists nowadays most readily ascribe: humour, that is a minimal, all too easy to miss, hijacking or deflection in the way of presenting a sign sequence or arrangement of objects.

In their passage from the critical to the ludic register, these procedures of delegitimization have almost become indiscernible from those spun by the powers that be and the media or by the forms of presentation specific to commodities. Humour has become the dominant way in which to exhibit commodities, with advertising now increasingly used to play on the undecidability between a product's use-value and its value as a sign- and image-support. In a society which functions within the accelerated consumption of signs, playing on this undecidability is the only remaining form by which to subvert the meaning of protocols for reading signs.

A consciousness of this undecidability works a displacement of artistic propositions into the second form, that of the *inventory*. The encounter of heterogeneous elements no longer aims to provoke a critical shock or to play on that shock's undecidability. The same materials, images and messages, once scrutinized according to the rules of suspicion, are now subject to a converse operation: repopulate the world of things, seize back their potential for

the shared history that critical art dissolved into manipulable signs. The arrangement of heterogeneous materials becomes a positive recollection, and in two forms. First, it forms an inventory of traces of history: i.e. objects, photographs or simple lists of names testifying to a history and a world in common. In 2000 an exhibition in Paris called *Voilà: Le monde dans la tête* endeavoured to sum up the twentieth century by means of various installations and photographic exhibits. The point was to reassemble experiences in such a way that indeterminate displays of objects, names and anonymous faces would all speak and interact in structures of reception. First welcomed under the rubric of play, the visitor encountered a multicoloured bed of dice by Robert Filliou, then proceeded through an installation by Christian Boltanski, *Les Abonnés du téléphone*, which consisted of telephone directories of various years and countries that anyone could, at leisure, pull off the shelves and peruse at the tables set up for that very purpose. There was also a sound installation by On Kawara which, for the artist, was evocative of some of the 'last forty thousand years gone by', as well as Hans-Peter Feldmann's presentation of one hundred photographs of one hundred persons aged from one to one hundred years. Among other works were a glass-covered photographic display by Peter Fischli and David Weiss, *Monde visible*, resembling a family photo album, and Fabrice Hybert's collection of bottles of mineral water.

In this logic, the artist is at once the archivist of collective life and the collector/witness of a shared capacity. In bringing together the art of the plastic artist with that of the *chiffonnier*, the inventory gives a prominent place to the potential of objects and images in terms of common history; it also shows the kinship between inventive acts of art and the multiplicity of inventions of the arts of doing and living that make up a shared world – bricolage, collections, language games, materials for demonstrations, etc. In the space reserved for art, the artist strives to render visible the arts of doing which exist scattered

throughout society.[18] With this twofold vocation of the
inventory, the political/polemical vocation of critical art
tends to transform into a social or community-oriented
vocation.

The third form marks this shift. I have baptized it
encounter, but it would be just as appropriate to call it
invitation. Here the artist acts as a collector who sets up
a reception area and appeals to the passer-by to engage in
an unexpected relation with someone – for example
Boltanski's installation of telephone directories, in which
the visitor was invited to take a phone book off the shelf
and sit down at a table to consult it. Later on in the same
exhibition, he or she was invited by Dominique Gonzales-
Foerster to take out a book from a pile of paperbacks
and sit down to read it on a rug depicting a desert island
reminiscent of a childhood dream. In another exhibition,
Rirkrit Tiravanija made sachets, camping-gas and a kettle
available to visitors so that they could prepare themselves
a Chinese soup, then sit down and engage in discussion
with the artist or other visitors. Corresponding to these
transformations of the exhibition space, diverse forms of
intervention into everyday urban space have also emerged:
the altering of signalling at a bus shelter to transform the
trajectory of everyday necessity into an adventure (Pierre
Huyghe); inverting the relationship between the au-
tochthon and the foreigner by placing electronic graffiti in
Arabic letters or a loudspeaker in Turkish (Jens Haaning);
or making an empty pavilion available to a suburb's inhab-
itants for their socializing wishes (Groupe A 12). Relational
art thereby aims no longer to create objects, but situations
and encounters. In so doing, however, it relies on a sim-
plistic opposition between objects and situations, effecting
a short-circuit where the point is to carry out a transfor-
mation of those problematic spaces that once contrasted
conceptual art with art objects/commodities. The former

[18] Michel de Certeau, *Les Arts de faire*, Paris: Union Générales d'Éditions,
1980.

distance taken with respect to goods is inverted and a proposition made about a new proximity between individuals, about building new forms of social relations. Art no longer tries to respond to an excess of commodities and signs but rather to a lack of bonds. As the main theoretician of this school puts it: 'Through little services rendered, the artists fill in the cracks in the social bond.'[19]

The loss of 'social bond' and the incumbent duty of artists to repair it – these are today's directives. But the report of loss may be given a more ambitious gloss. Not only are we alleged to have lost forms of civility but also the very meaning of the co-presence of beings and objects constitutive of a world. The fourth form, that of mystery, sets out to remedy exactly that. Wanting to apply it to cinema, Jean-Luc Godard brought the category of mystery back into fashion, a category which, since Mallarmé, has designated a certain way of linking heterogeneous elements. Mallarmé's work, for instance, combines the thought of the poet, the steps of a female dancer, the opening of a fan, the foam of a wave and the undulating of a curtain blown about by the wind; while Godard juxtaposes Carmen's rose, a Beethoven quartet, the foam of waves on a beach evoking Virginia Woolf's *The Waves*, and the elan of amorous bodies. The sequence of *Prénom Carmen* as summarized here aptly betrays a shift in logic. The selection of linked elements in fact belongs to a tradition of *détournement*: the Andalusian mountain becomes a weekend beach; romantic smugglers crazy terrorists; the tossed flower of which Don José sang is now only a plastic flower; and Micaela murders Beethoven instead of singing songs by Bizet. But the *détournement* here no longer has great art's function of political critique. On the contrary, it effaces the picturesque imagery to which critique was attached in order to revive Bizet's characters from the pure

[19] Nicolas Bourriaud, *Relational Aesthetics*, trans. Simon Pleasance and Fronza Woods, Paris: Presses du Réel, 2002, p. 36 (French original, 1998).

abstraction of a Beethoven quartet. It makes gypsies and
toreadors fade out into the fusion music of images which
unite, in one and the same breath, the noises of strings, of
waves and of bodies. In contrast to dialectical practice,
which accentuates the heterogeneity of elements in order
to provoke a shock that reveals a reality riven by contra-
dictions, mystery emphasizes the connection between het-
erogeneous elements. It constructs a play of analogies in
which these heterogeneous elements testify to a world in
common, in which the most disparate realities appear to
be cut out of the same sensible fabric and are always open
to being linked together by what Godard calls the 'frater-
nity of metaphors'.

'Mystery' was the central concept of symbolism. And
Symbolism is without doubt back on the agenda. By this
term I am not referring to the spectacular and somewhat
nauseating forms such as the resurrection of Symbolist
mythologies and Wagnerian fantasies about the total work
of art in Matthew Barney's cycle *Cremaster* (1997–9). I
am thinking of the more modest, sometimes imperceptible
way in which the arrangements of objects, images and
signs displayed in contemporary exhibitions have shifted
from a logic of provocative dissensus to that of the mystery
testifying to co-presence. Elsewhere I have discussed the
photographs, videos and installations presented in an exhi-
bition called *Moving Pictures*, held at the Guggenheim
Museum in New York in 2002.[20] This exhibition aimed to
point to the continuity of contemporary works with the
artistic radicality of the 1970s *qua* critique of artistic
autonomy and dominant representations. But, like Vanessa
Beecroft's videos exhibiting nude and inexpressive femi-
nine bodies in museum space, the photographs by Sam
Taylor-Wood, Rineke Dijkstra and Gregory Crewdson
showing bodies of ambiguous identity in uncertain spaces,
or the light bulbs illuminating walls carpeted with anony-
mous photographs from Christian Boltanski's darkroom,

[20] Rancière, *The Future of the Image*, pp. 63–4.

the still-invoked interrogation of perceptual stereotypes veered towards a wholly indifferent interest in the indefinite boundaries between the familiar and the foreign, the real and the symbolic that had fascinated painters at the time of Symbolism, metaphysical painting and magical realism. On the upper level of the museum, a video installation by Bill Viola beamed onto the four walls of a dark room flames and floods, slow processions, urban wanderings, wakes and ship embarkation, to symbolize, in addition to the four elements, the great cycle of birth, life, death and rebirth. Experimental video art thus manifests in plain language the latent tendency of many of today's *dispositifs* by miming, in its own way, the great frescos of human destiny so admired by the Symbolist and Expressionist age.

These categorizations of course remain schematic. Contemporary installations and exhibitions confer on the couple 'exhibit/install' several roles at once; they play on the fluctuating boundary between critical provocation and the undecidability of its meaning, and between the form of the exhibited work and that of the instituted space of interaction. The *dispositifs* of contemporary exhibitions often either cultivate this polyvalence or are subject to its effects. The exhibition *Voilà*, for example, presented an installation by Bertrand Lavier, *La Salle des Martin*, which gathered together fifty-odd paintings, many of which came from the storerooms of provincial museums, with only one point in common, that of an author's name, the most widespread family name in France, Martin. The original idea behind this installation was to undermine the meaning of works and the hallmarks of conceptual art. But in this new memorial context the installation took on a new signification, attesting to the multiplicity of more or less ignored pictorial potentials and registering the lost world of painting in the memory of the twentieth century. The multiplicity of meanings ascribed to the same works is sometimes presented as testimony to the democracy of art, refusing to disentangle any given complexity of attitudes

and labiality of boundaries insofar as they reflect the complexity of the world.

The contradictory attitudes that today are being drawn from the great aesthetic paradigms express a more fundamental undecidability in the politics of art. This undecidability is not due to a postmodern turn. It is constitutive: aesthetic suspense immediately lends itself to being interpreted in two ways. Art's singularity stems from an identification of its own autonomous forms both with forms of life *and* with political possibilities. These possibilities can never be integrally implemented except at the price of abolishing the singularity of art, that of politics, or both together. Today, coming to terms with this undecidability sparks differing sentiments: with some, a melancholy relating to the world in common that art once carried in it, if only it had not been betrayed by political enlistments and commercial compromises; with others, an awareness of its limits, a tendency to play on the limitation of its power and even the uncertainty of its effects. But the paradox of our present is perhaps that this art, uncertain of its politics, is increasingly encouraged to intervene due to the lack of politics in the proper sense. Indeed, it seems as if the time of consensus, with its shrinking public space and effacing of political inventiveness, has given to artists and their mini-demonstrations, their collections of objects and traces, their *dispositifs* of interaction, their *in situ* or other provocations, a substitutive political function. Knowing whether these 'substitutions' can reshape political spaces or whether they must be content with parodying them is without doubt an important question of our present.

The Antinomies of Modernism

Alain Badiou's Inaesthetics: the Torsions of Modernism

Petit Manuel d'inesthétique: this is the title under which Alain Badiou gathers his principal interventions on the question of art. The only introduction he gives to this new concept of 'Inaesthetics' is contained in the following two sentences: 'by "Inaesthetics" I understand a relation of philosophy to art that, maintaining that art is itself a producer of truths, makes no claim to turn art into an object for philosophy. Against aesthetic speculation, Inaesthetics describes the strictly intraphilosophical effects produced by the independent existence of some works of art.'[21]

These two sentences raise an initial question. They assert the proposition peculiar to Badiou of a relation which is a non-relation between two things, each one of which relates only to itself. But they situate this singular proposition in a very consensual configuration of contemporary thought. From the analytic denunciation of speculative aesthetics to the Lyotardian denunciation of aesthetics as nihilistic poison, today a whole swathe of discourse is in agreement to proclaim that a radical separation exists between the practices specific to art and the malefic

[21] Alain Badiou, *Handbook of Inaesthetics,* trans. Alberto Toscano, Stanford: Stanford University Press, 2005, p. 1 (French orignial, 1998).

enterprise of aesthetic speculation which is always taking hold of its idea and denaturing it. In order to identify inaesthetics, it is necessary to grasp the logic that inscribes its singularity in this great anti-aesthetic consensus. In so doing, the first requirement is to identify the reason for this consensus itself. This reason, it seems to me, can be put as follows: denouncing art's 'denaturation' at the hands of aesthetics serves as an assurance that it has a 'nature' or, if you will, the univocity of a name. Hence, it works, as a result, to assure the actual existence of a uni-vocal conception of art, realized in the autonomous singu-larity of works, invariant in the diversity of artistic practices and tested in a specific experience. In a nutshell, the denun-ciation of aesthetic usurpation works to guarantee the 'specificity of art'. It assures the identification of this 'spe-cificity'. Which is to say, conversely, that the name of aesthetics is the name that problematizes this specificity, or that is the univocity of its concept, the relation of its unity to the plurality of arts and the modes for recognizing its presence.

There are in fact three major philosophical attitudes concerning the identification of art and the arts. I will recall them by following, but with a slight twist, the summary that begins Badiou's essay entitled 'Art and Philosophy'.[22] The first, to which Plato's name is attached, can be epitomized as follows: there are *arts*, that is to say applications of forms of knowledge founded on the imita-tion of models; and there are *appearances*, the simulacra of arts. There are true and false imitations. In this division, *art* as we understand it is an undiscoverable notion. This is why there is no point lamenting that Plato 'subordinates art to politics'. Plato, indeed, does not subordinate art to anything. Far more fundamentally, what we call art makes no sense to him. What he conceptualizes is the poem inas-much as it educates, and it is in this relation that he raises these questions: to what end and by what means does it

[22] Ibid., pp. 1–8.

educate? Art, then, is disjoined from the truth, not only in the simple sense in which the true stands in contrast to the simulacrum, but in the sense that the division of the true and the simulacrum prohibits any identification of its place.

The second form – Aristotelian, in a word – identifies art within the *mimesis/poiesis* distinction. According to this form, there exist various *arts*, that is forms of know-how, *some* of which execute specific things: namely, imitations or arrangements of represented actions. These latter are not subject either to the ordinary verifications of art products according to utility or the truth's legislation relating to discourse and images. Art does not exist as an autonomous notion. But there exists a criterion of discrimination within the general field of *tekhnaï*, namely imitation, which functions in three ways. In the first instance, it is a principle that distinguishes, among the arts, a specific class endowed with specific criteria. But it is also a principle of inner normativity specified by rules and criteria of recognition and evaluation that allow one to judge whether an imitation really is art, whether it adheres to criteria of good imitations in general as well as to those of a specific art, or genre, of imitation in particular. Furthermore, it is a principle of distinction and comparison which allows one to compare the diverse forms of imitation. It is thus that the representative regime is defined, a regime in which art does not exist as the name of a specific domain, but in which there exist specific criteria of identification, concerning what it is that the arts make and the appreciation of how it is done, whether good or bad.

The third form is an aesthetic regime in which art is no longer identified as a specific difference within ways of doing or through criteria of inclusion and evaluation, allowing one to judge artistic conceptions and applications, but as a mode of sensible being specific to its products. These latter are characterized by their belonging to the mode of being of a sensible element that differs from

itself, identical with a form of thought that also differs from itself. In this regime, art comes to be identified as a specific concept. However, it comes to be identified only by the non-appearance of criteria that separate its ways of doing from other ways of doing. Indeed, since what *mimesis* involved, in a nutshell, was not the obligation of resemblance – with which schoolchildren and a good number of their teachers stubbornly identify it – but a principle of division within human activities, one that delimits a specific domain enabling objects to be subsumed under concepts and classes of objects to be compared. *Mimesis* separated out what was art from what was not. Conversely, all the new, *aesthetic* definitions of art that affirm its autonomy in one way or another say the same thing, affirm the same paradox: that art is henceforth recognizable by its lack of any distinguishing characteristics – by its indistinction. Its products perceptibly manifest a quality of a thing that is *made* that is identical with the *not made*, a *known* thing identical to the *unknown*, a *willed* thing identical with the *unwilled*. In short, the specificity of art, finally nameable as such, is its identity with non-art. With this, art at last positively comes within the ambit of truth. Not because art is alone affirmed as capable of truth – this is the thesis that Badiou attributes in all unfairness to German Romanticism – but because it is art only inasmuch as it falls under this category. And it belongs there because it is the attestation in the sensible, in its sensory difference with respect to the ordinary regime of the sensible, of the pass of the idea. In this regime, art exists because eternity comes to pass, because the new mode of eternity is to pass.

A consequence follows from this: if eternity only 'comes to pass', its effect is not, not at any point, identifiable with the accomplishment of a determinate form in a specific materiality. It always lies within the difference between what comes to pass and that through which it passes. The immanence of thought in the sensible immediately splits into two. The form is the form of a pure pass and, at the

same time, a moment in the history of forms. The principle of the idea's immanence to sensible presence instantly flips over into a principle of gap. The idea avoids becoming embedded in the situation in which it comes to pass only because it is always ahead of or behind itself, according to a necessity nicely captured by the famous Hegelian quandary: if a thing of the past is art for us, this is because its presence in general is a presence in the past; that in its supposed present, it was something other than art – a form of life, a mode of the community, a manifestation of religion.

In this way, the aesthetic identification of art – insofar as it is the manifestation of a truth *qua* pass of the infinite in the finite – links this pass from the outset to a 'life of forms', a process of the formation of forms. And, in this process, all the criteria of differentiation between art forms and the life forms of which they are the expression, as well as between art forms and the forms of thought that enable their reprise, vanish. The same goes for the principles of differentiation between the arts and, ultimately, for the very difference between art and non-art. In sum, the aesthetic autonomy of art is only another name for its heteronomy. The aesthetic identification of art is the principle of a generalized disidentification. This begins with Vico's poetic revolution, and his assertion that Homer was a poet because he had not desired to be one, because he merely expressed the knowledge that men in his time had about themselves in the only way that they could express it;[23] it then continues with Balzac's assertion in *La Peau de chagrin* that the new era's great poet is not a poet but the geologist Cuvier,[24] not to mention with the indiscernibility

[23] Giambattista Vico, *The First New Science*, ed. and trans. Leon Pompa, Cambridge: Cambridge University Press, 2002 (Italian original, 1725); Rancière, *La Parole muette*, Paris: Hachette Littérature, 1998.
[24] Honoré de Balzac, *The Wild Ass's Skin*, Harmondsworth: Penguin Classics, 1977 (French original, 1831); Rancière, *L'Inconscient esthétique*, Paris: Galilée, 2001.

between Balzac's writing *qua* great novelist and Balzac as the writer of a book of *Physiologies* about dietary issues; it again continues its way via the Rimbaudian searching for the gold of the new poem in simple-minded refrains and idiotic paintings, and with the Flaubertian sentence which risks at every moment turning into one by Paul de Kock; and also with those non-identified objects that are the prose poem or the essay – for example, Proust's 'essay' about Sainte-Beuve which turns into that deceptively auto-biographical novel known as *À la Recherche du temps perdu* and closes with an outline of a theory of the book contradictory to its own unfolding. There is no need to continue this indeterminable list of disorders that identify art. I have given only its 'literary' examples precisely because it was first under the name of 'literature' that this disorder impacted upon the art of writing before its blur-rings and quarrels [*brouil-lages*] spread to the fields of the visual, and the so-called plastic, arts.

Against this modern disorder, a rampart has been invented. This rampart is called *modernism*. Modernism is a conception of art which holds onto the aesthetic iden-tification of art but refuses to accept the forms of disiden-tification in which it is carried out; it wants to hold onto art's autonomy but refuses to accept the heteronomy that is its other name. To counter its lack of follow-through and establish its own beautiful chain of reasoning, mod-ernism has contrived an exemplary fable in which art's homonymy is tied to the contemporaneousness of an era. This fable merely identifies art's modern revolution with the discovery of its finally disclosed, pure essence. The retreat of *mimesis* here is likened to an insurrection which, for a century now, is supposed to have released the arts from the obligation of representation and enabled the dis-covery of art's proper end, hitherto perverted by an extrin-sically imposed finality. The aesthetic identification of art is thus referred back to the process of autonomization specific to each art, henceforth devoted to demonstrating its potentials for producing thoughts immanent to its

determinate materiality. Literary modernity thus comes to consist in the exploitation of the pure powers of language, freed from the obligation of communication; pictorial modernity, the conquest, by a type of painting set free from naked women and combat horses, of the powers intrinsic to its bi-dimensional surface and the materiality of coloured pigment; and musical modernity, in a twelve-note language that bears no analogy to expressive language. A 'specificity of art' is thereby defined which each art allegedly realizes by its own specific means, means that are fully distinct from those of its neighbouring art. By the same token, it is claimed, this also substantiates the global distinction between art and non-art.

This identification of art's specificity with the specificities of arts that wisely stick to their respective places was never particularly well theoretically founded. And it is less and less tenable in practical terms, given the reality of all the melanges which, for a century now, have characterized art's development, notwithstanding the periodic discovery of new 'New Laocoöns' that, following Lessing's own discovery, put anew the case for the existence of the *arts*, each one in its radical separation.[25] This is why the denunciation of everything that blurs the boundary between art and non-art, and especially of art's capture in discourse about art in general and in philosophical discourse in particular, increasingly serves to proclaim 'art's specificity'. Contemporary 'anti-aesthetics' is, then, the defensive form of modernism, unremitting in its attempt to exorcize from 'its' version of the 'specificity of art' that aesthetic regime of art which brings art into being, but only at the price of disappropriating it.

How are we to situate *inaesthetics* within the anti-aesthetic consensus to which today's consensus has restored yesterday's modernist one? We can clearly discern some of

[25] Clement Greenberg, 'Towards a Newer Laocoon', in *The Collected Essays and Criticism*, Chicago: Chicago University Press, 1986.

the characteristic traits of modernism in Badiou's prob-
lematization of art: for instance, there is a claim about art's
modernity, understood as anti-*mimesis*, in the sense that
it is set free from the obligation of imitation of external
reality; there is a thesis that states that art's truths are
absolutely specific to it alone and that asserts a strict
delimitation between art and the discourse on art; and
there is an assertion claiming the existence of an inviolable
line separating each of the arts. In Badiou's work, however,
these modernist claims do not piece together to form
the usual figure of modernism. The reason for this, as it
happens, is that Badiou denies that the specificity of the
arts resides in their respective *languages*. Their specificity,
he claims, resides in their *ideas*. And if the hero of his
conception of art is the hero of literary modernity, as it
was taken to be in the times of *Tel Quel* and structuralism,
namely the Mallarmé of the virginal night of *Igitur, Un
Coup de dés* and the *Sonnet en X*, he nonetheless does not
identify on literary modernity's page the essence – pure or
opaque – of language, but instead the pass of the Idea. In
short, Badiou's incontestable modernism is a modernism
with a twist. The supposed single and modern essence of
art 'such as it is in itself' is twisted, even twisted twice over,
by Badiou's essential project, by what can be called his
ultra-Platonism, most succinctly encapsulated in the idea
of a Platonism of the multiple.

The torsion to which he subjects straightforward
modernism must therefore be understood in terms of a
project with an already long history, that of reconciling
the Platonic condemnation of images with the affirmation
of art's specificity. Historically, this project has taken two
major forms. There is the mimetic form, that of the neo-
Platonism of the Renaissance, which received expression
in Panofsky's *Idea* (1924). This form consists in returning
the 'false' imitation to the truth by making of the artist a
contemplator of the eternal Idea, shining forth its reflec-
tion in sensory appearances. This pictorial neo-Platonism,
which posits the image's resemblance to the Idea, cannot

be that of Badiou. For him, it is not a question of redeeming art by giving the Idea sensible *analoga* and having the eternity of the model reflect itself on the picture surface. Instead, to be really Platonic, to be Platonic in the modern manner, consists, for Badiou, in having the Idea's Platonic eternity transpire within a radicalized notion of anti-*mimesis*. It consists in having an Idea set free from resemblance transpire in a form that totally dissembles it, in a form that Platonism itself totally rejects and by which it is interminably rejected in return: namely, the obscurity of situations and the *faux-semblants* of the theatre. For Badiou, Platonism as the immortal Idea's triumph over all that is sensuous and mortal can be valid only if its demand is embodied by some hedonistic, ruffian and barefaced liar of a character from a comedy. This is the reason why Badiou has put forward a contemporary version of the *Fourberies de Scapin*, whose protagonist is an Arab inhabitant of the outlying suburbs.[26] Platonism is of worth only as the identity of Platonism and anti-Platonism.

But this Platonism as the identity of contraries cannot be separated from neo-Platonism except via its rapprochement to a second 'Platonism of art': namely, the Platonism of the aesthetic age which, as elaborated by post-Kantian Romanticism and idealism, has the Idea transpire as a pass in the sensible and turns art into the affirmation of this pass. This Platonism depends upon the aesthetic figure of the Idea *qua* self-differing thought, and is manifested in a self-differing sensible. Badiou is obliged to accept a certain proximity between his 'Platonic modernism'[27] and the aesthetic determination of art which, properly understood, shatters the modernist paradigm. It is in vain that he tries to rid himself of it in the above-cited essay 'Art and Philosophy', which assigns the aesthetic identification of

[26] Badiou's 'Ahmed' tetralogy of plays comprises *Ahmed le subtil*, *Ahmed philosophe*, *Ahmed se fâche* and *Les Citrouilles*, Arles: Actes Sud, 1994–6.

[27] Badiou, *Handbook of Inaesthetics*, p. 14.

art to the specific theory of Romanticism and expeditiously identifies Romanticism with Christology, in other words with a fetid compassion for the suffering and mortal body. These hasty amalgamations leave totally intact the problem they want to exorcize. Indeed, at issue is not to have to choose between the mortal body and the Idea's eternity. At issue is to define the status of the passing of this eternity.

In Badiou's work, everything hangs on the image inherent to Romantic art in Hegel's sense, that not of the cross but of the empty tomb – a tomb missing an Idea that has returned to heaven never to redescend. At issue is not the struggle between death and immortality. That struggle, precisely, has already been concluded. At issue is to know *where* this Resurrected has passed, for which one searches here in vain. The Hegelian scenario encapsulates the status of art and the truth in which they incessantly run ahead or behind themselves, in which the statue's eternity is constituted by the impossibility of any religion's thinking the Eternal, and the elan of a cathedral spire by the impossibility for a form of thought that has found the Eternal to give it a sensible figure. What is at stake is not some morbid praising of the suffering flesh, but the voyage of eternity insofar as it is always caught between the silence of the stone and thought's returning to itself. Around the empty tomb indeed we can sense the shadows of all that which threatens the Platonic/anti-Platonic pass of the Idea in art: not at all the suffering but the glorious body of the Church or of the community, the becoming-philosophy of the poem, the becoming-image and the imagery of the coming of the Eternal, the becoming-museum and the becoming-archaeology of art; in sum, all the forms by which the sensible is absorbed in the Idea and the Idea in the sensible exacted by the aesthetic identification of art. Indeed, all Badiou's analyses of poems and artworks return us to that same primitive scene, which is always replayed in the same manner. At issue, each time, is to make appear, in the empty tomb, not a vanished body, nor even an idea, that

reascends to the sky, but the immortality present in the Angel's variegated wings and speech, which announces that, once again, its pass avers the Idea: the angel of the Resurrection, the angel of the Annunciation, averring, like the Rimbaudian genius, that he will come to attest anew to the event, each time begun anew, of the advent of the Idea. The key stake here is to make the pass abide, to make the inconsistency of the pass of the Idea inhere forever by preventing it from getting lost, whether in the muteness of things, or in the interiority of thought. The pass of the Infinite must be isolated from its aesthetic site, from the life of forms, from the Odyssey of the spirit foreign to itself.

Badiou has therefore to slice the sharp Platonic scalpel within the indiscernibility of aesthetics between the forms of art and those of life, the forms of art and those of the discourse on art, the forms of art and those of non-art. Within the romantic Platonism which affirms that art is anti-mimetic, that it depends on the truth and its pass, Badiou must bring another Platonism to bear, an original Platonism which puts to work – precisely by pluralizing truth into so many discrete truths – an eternity that starts over and over again in the act of an integral consumption of the sensible. He wants eternity to pass in the ever renewed separation which shines the Idea forth in the fading of the sensible, to affirm the absolutely discrete and always similar character of the advent of the Idea, by not allowing its cipher to disappear in the muteness of stone, the hieroglyph of the text, the décor of life or the rhythm of the collective. He wants this less for the purpose of reserving a specific domain for poetry or art than of preserving the educative value of the Idea.

This is because to be a Platonist also means maintaining that, in the last resort, the question of the poem is an ethical one, that the poem and art consist in education. Aesthetic Platonism in general involves the paradox of the education imparted from the truth specific to art. This can be understood in two ways, however. On the one hand,

there is Romantic educational formation [*Bildung*], which is to say an identification of art's forms with the forms of a life of self-cultivation. On the other, there is Badiou's ultra-Platonism, according to which only one thing educates, namely the contemplation of ideas. And therein lies the whole paradox of Badiou's Platonist modernism: the same reason that distances him most from the modernist creed of art's autonomy also compels Badiou to adopt, in paradoxical companionship, some of its fundamental propositions. For instance, he needs to affirm several things: that there is a specificity of art, or the poem, exposed in its purity only with the advent of modernity; that this specificity is the manifestation of a self-sufficient truth wholly separate from any discourse whatsoever about art's finality; and, lastly, that the 'specificity of art' is always the specificity of *an* art. But he needs to do so not via the ordinary modernist faith in the specificity of each art's 'language', but because it is the condition of separation by which the Idea is attested and enables its exhibition to educate. And he has to do so by risking a paradox: that of grounding art's anti-mimetic division into categories which in fact belong to the logic of *mimesis*.

I am thinking, for example, of the recurrent opposition that Badiou makes between the thinking immanent to the Mallarmean poem and Mallarmé's declarations on poetry. In fact, the only criteria by which to ground this opposition between the thought *of* the poem and discourse *about* the poem are those of the traditional distinction between verse and prose. But, the aesthetic regime of arts in general, and Mallarmé's poetics in particular, deprive the opposition between the essay in prose and the poem in verse of all discriminatory relevance: *Crise de vers* is not a text by Mallarmé *on* poetry; it *is* a piece of Mallarmean poetry, neither more nor less so than the *Sonnet en X*, which, for its part, is indissolubly a poem and a statement *about* poetry. I am also thinking of Badiou's assertion identifying modernity with anti-*mimesis*: 'The modern poem is the

opposite of a *mimesis*. In its operation, it exhibits an Idea
of which both the object and objectivity represent nothing
but pale copies.'[28] The act by which Badiou imposes the
cut manifestly exceeds the discriminating power of the
statement itself. This latter is merely a reprise of the idea
that founds the mimetic regime, which is affirmed in
chapter 9 of Aristotle's *Poetics*, namely poetry's superior-
ity over history. More, the two Mallarmean lines by
which he hopes to illustrate the 'modern' rupture ('the cool
morning . . . if it resists/Murmurs no water that my flute
does not pour') say no more than these two lines from La
Fontaine, which I have a custom of using as typically illus-
trative of the mimetic regime: 'The charms that Hortésie
pours forth under her shades/Are more beautiful in my
verses than in her own workings.' The expression by which
Badiou hopes to encapsulate anti-mimetic modernity is in
fact the most traditional formula of *mimesis*.

This attempt to ground the supposed anti-mimetic sin-
gularity of the modern poem in the most established prin-
ciples of mimetic art is not a circumstantial blunder. In
fact, what Badiou wants is less to preserve the Mallarmean
poem from *mimesis* than from *aisthesis*, that is to say from
an aesthetic identification of the pass of truth. Against
the Idea's embodiment, against its engulfment in sensible
matter, Badiou wants to affirm the Idea as pure subtrac-
tion, as a pure operation of the integral disappearance of
the sensible. But, also, he wants to avoid this subtraction
from totally vanishing, to have it dwell as inscription. He
wants to assure the problematic articulation of two prin-
ciples. First, that Idea is subtraction. Second, that every
subtraction is the positive operation of the inscription of
a name. There is art, for Badiou, inasmuch as there is a
naming. More, the pertinent concept, for him, is not art
but the poem. The essence of art, as for Heidegger, is the
essence of the poem. And this essence consists in inscribing,

[28] Ibid., p. 21.

in conserving evermore not the thing that has disappeared but the disappearance itself. This is why in Badiou's system of art only two forms are really necessary: the poem as affirmation, as inscription of the disappearance, and the theatre as the place where that affirmation becomes mobilization.

He therefore has to set about guaranteeing the poem's status as linguistic inscription. The operation is a difficult one, because it contravenes the poem's dispersion, a dispersion inherent to the aesthetic regime of arts, and of which his poet of reference, Mallarmé, is an eminent theoretician. Further more, the text in which Badiou sets down his thoughts on dance is, in fact, a settling of accounts with Mallarmé in Mallarmé's name. In a famous passage, the latter characterized the art of the dancer as 'a poem set free of any scribe's apparatus'. This affirmation is paradoxical, Badiou tells us, because 'the poem is by definition a trace, an inscription, especially in its Mallarmean conception'.[29] For my part, I would say that the 'definition' and 'singularity' are Badiou's and his alone. Because with Mallarmé the poem is always worded and laid out, not as the trace of an already transpired event, but as the very act of a tracing: the deployment of an appearing and of a disappearing which is laid out in analogy with the 'subject' of the poem – the movement of a fan, of a headdress, of a curtain, of a wave, of the streaming of the gold of fireworks or the smoke of a cigarette. It is this deployment in analogy which constitutes the poem as the effectiveness of the Idea. A consequence follows from this which Mallarmé sometimes accepts and sometimes dismisses, in order to preserve the poem's 'lucidity', the notion of thought put into words. This consequence is precisely the possibility that the poem can be 'set free of any scribe's apparatus', that it may consist in the way in which the legs of the illiterate dancer translate, without knowing it, the reverie of the spectator who lays a flower 'at her feet'. The reason

[29] Ibid., p. 66.

is that the poem proceeds in steps, unfolds in fabrics, is reflected in the golds of the hall and is refracted on the silk of the stoles.

Badiou wants precisely to preserve Mallarmé from all these movements of disappearance, all the brilliance of the variegation of the angel's wings, all these dispersions of his message. So he modifies the poet's text in order to change its meaning. Addressing his double, the spectator in the midst of reverie, Mallarmé purports to show him how the writing of the steps of the ballerina analogizes the 'nudity of *your* concepts'.[30] Badiou transforms this analogical relationship between two sets of thoughts into the metaphor of thought *itself* as that which is 'devoid of relation to anything other than itself'.[31] Dance expresses, he says, the nudity *of* concepts: no longer, then, does it form, as with Mallarmé, the schema specific to the singular 'dream' of the spectator-poet; instead, it is the minimal mode of sensory existence of Ideas in general. The gap between *poiesis* and *aisthesis*, which is defining of the veritable 'modern' specificity of the aesthetic regime of art, thus finds itself resorbed. Dance becomes the manifestation of the simple disposedness of bodies to welcome the pass of an idea. Thus, instead of Mallarmean analogy, a hierarchy of forms of art is established to shore up the status of art – and above all of the poem – as that which is productive of educative truths.

To do so, the Mallarmean corpus must be relieved of all those fans, postal addresses and verses covering sweet-wrappers, which comprise such a large part of it.[32] It is necessary, then, that the poem, in its disposition, not be the curve that the lines draw, but a protocol for the succession, substitution and inscription of names. Lastly, the Mallarmean poem must be placed under the jurisdiction

[30] Stéphane Mallarmé, *Divagations*, trans. Barbara Johnson, Cambridge, Mass.: Harvard University Press, 2007, p. 134 (French original, 1897).
[31] Badiou, *Handbook of Inaesthetics*, p. 66.
[32] Mallarmé, *Vers de circonstance*, ed. Bertrand Marchal, Paris: Éditions Gallimard, coll. 'Poésie', 1996.

of a twofold assertion to ensure both the poem's irreducible autonomy and the need of a philosopher who 'discerns its truths'. This is the twofold axiom that Badiou posits: first, that the poem 'thinks itself' in a non-reflexive mode. Because it is non-reflexive, it rules out there being any poem of the poem. But because it generates its own thought, it condemns any intervention by any philosophy which would utter this thought. Second, the poem's operation of thought consists precisely in *subtracting* its own thought and it thereby gives rise to the philosophical task of discerning the truths that it subtracts. In this way, the second axiom reserves the poem's thought to a philosophy which the former has opportunely set free from all competition.

But what exactly is thereby *discerned*, that is to say, at the end of the day, *named*? As always, it is the status of the poem both as affirmation and as a metaphorization of the Idea's transpiring. If dance is said by Badiou to be *the* metaphor of thought, i.e. a manifestation of the capacity of bodies for truth, we may say that, in his work, the general status of art's manifestations is to signify and to symbolize the pass of an idea, to show that a body is open to such, that a place can welcome it, a collective be seized by it. Badiou thus reprises in his own way the Hegelian schema of symbolic art. Like Hegel, he distributes the arts according to their ascending power of speech. With Hegel, architecture is the first art; it is the silent art that strives in vain to speak purely through its elevation towards the sky. With Badiou the same role is fulfilled by dance, whose elevation shows that thought may visit bodies. Dance performs this task in showing that the earth can become air. But, for Badiou, this debut of art cannot be a silent language. It must already be an affirmation. The metamorphosis of earth into air is a *naming* of the earth.[33] On this point, it is important to see the double sense of the word.

[33] 'Yes, dance is indeed – each and every time – a new name that the body gives to the earth.' Badiou, *Handbook of Inaesthetics*, p. 71. It would be interesting to compare this *nomination* of the earth with the Heideggerian thought of the poem.

The movement which elevates the earth by designating it is what enables dance to be elevated among the arts, named at the rank of an art, albeit at the lowest rung on the ladder, on the top rung of which the poem, as inscription of the name, has pride of place.

For this, it is necessary to fasten the poem to the affirmation of the name, tear its words from that destiny in which they circulate between fossils and hieroglyphs, between glorious bodies and movements of fans, between idiotic paintings and the singing of peoples, in which the *aesthetic* regime of the poem has unceasingly forced it to wander, from Novalis to Proust or from Balzac to Mallarmé and Rimbaud; by the same token, it is forced to wander not only through music, painting and dance, but even typography, the decorative arts or pyrotechnics. Badiou refers the poem to the Platonic order of the *logos*. He turns this *logos* into the specific maxim of the courage of thought in general. The poem thereby becomes an orientation for thought, and we know Badiou's taste for extracting maxims from poems and giving them a general value: 'We assert you, Method' (Rimbaud), or: 'on inconsistencies, lean' (Celan). But at the same time he dismisses the notion that the poem's orientation of thought might be self-sufficient. And so it is that it falls to philosophy to discern the orientations that the poem dictates. This move supposes that the inscription of the name and the utterance of the maxim are posited as the effects of the form-poem. This form must therefore be reduced to an apparatus for naming and this apparatus posited as the *thought* that the poem subtracts. In rigorously Althusserian logic, philosophy is therefore called upon to discern those truths that the poem throws up as enigmas, only miraculously to find its own truths there, the very ones of which it was said to have been deprived. In this way philosophy can recognize that the 'duty' of the 'family of irises' (*Prose pour des Esseintes*) is nothing but the 'duty of thought', that the duty of thought is to 'decide at the point of the undecidable', and that it is precisely this exigency to make a decision on the undecidable that is at stake in the question of knowing whether

there has been a shipwreck nearby or whether the foam is not rather the trace of the flight of a siren who had been poking a bit of fun at us (Hushed to the crushing cloud/*À la nue accablante tu*).[34] As a result, the Mallarmean poem, in itself already an allegory of the poem, with Badiou becomes an allegory of the event in general and of the courage of the effort of thought whereby its ordeal is kept alive. So, every poem says one and only one thing. Every poem is comparable with every other poem that yields to the same demonstration, that can be assigned the same task of talking twofold, of expressing the same event of the Idea both as affirmative maxim and as subtractive enigma.

So the poem is literally a *mimesis* of the Idea, accomplishing at once its Platonic-ethical vocation to affirm and its Hegelian-aesthetic vocation to dissimulate thought. This twofold statement simultaneously makes it possible to set the poem at a remove both from its Romantic entanglement in the humus of fossils and its Symbolist evanescence in fanned movements. Badiou thereby claims to have avoided two problems: that of the 'poem of the poem' and that of making philosophy a philosophy of the poem. But he avoids them only in appearance. This is because, in his analysis, 'enigma' is reduced to the metaphor in which philosophy recognizes the 'thought of the poem' in image, that is the thought of the truth-event, which it finds doubly expressed by the poem, both in the affirmation of maxim and in the transparency of metaphor; these last two are separated from one another by an incessantly crossed stream of too little depth. Here, then, the tying – or 'suturing', as Badiou would say – of philosophy to the poem occurs through its very denial. The poem says only what philosophy has need of it to say, which the latter feigns to discover in the surprise of the poem. This denied tie, this tie by negation, is not inadvertent. It is the only way for Badiou to assure the

[34] Badiou, *Conditions*, trans. Steven Corcoran, London, Continuum, 2008, pp. 49–53 (French original, 1992).

necessary and impossible coincidence between two contra-
dictory demands: the Platonic/anti-Platonic demand for a
poem that informs us of truth's courage and the modernist
demand concerning the autonomy of art.

What Badiou says about dance can be generalized to
his whole system. When extracting its principles, Badiou
emphasizes that it is not dance 'itself' that is at issue, its
technique and its history, but dance 'such as it is given
welcome and shelter by philosophy'.[35] For him there are
only truths of dance under the shelter of philosophy, that
is to say in the tying of philosophy and dance. The objec-
tion will be put that such a proposition is specific to dance,
and that, precisely, for Badiou dance is not a true art. Also,
philosophy can and must be tied to dance to extract from
its *movements* the *signs* of the native disposition of bodies
to truth. But we can invert the problem by raising the
question of the place of this 'art which is not an art'. We
can then ask if Badiou's own classification of the arts is
not designed to ensure the inviolate 'specificity' of art and
the purity of each art, by relegating the tie between art and
that which is not art – whether it is philosophy or the
misery of the world – to a residence, to the borders. We
shall ask, by the same token, whether there are no tensions
to be found at these borders that undermine the tying of
Platonism and modernism under the rubric 'inaesthetics'.
The system of art in Badiou's work looks, indeed, to be a
well-guarded fortress, a fortress guarded by those that it
places at the door – at *its door* – those who get lumbered
with all the misery of non-art and the equivocations of the
tie, and who thereby protect the void of the central place
where the virginal purity of the poem sits enthroned. But
these obscure negotiations on the perimeter are perhaps
ripe to produce a new confrontation between Badiou's
thought and the modernist vulgate.

This tension is palpable, as we saw, in his analyses of
dance. On the one hand, the philosophical 'shelter' given

[35] Badiou, *Handbook of Inaesthetics*, p. 63.

to the latter is a way of bringing the scalpel of separation into the Mallarmean analogy between dance and the poem. But, at the same time, the tie thereby *declared* between the 'movements' of an art and the 'concepts' of philosophy undermines the entire edifice of denegation. It returns to the 'centre' and forces a new consideration of the *aesthetic* tie between the productions of art and the forms of thought pertaining to art. The concepts with which Badiou has expanded his system – whether the general notion of *con-figuration* that he uses to think through the subject of art, or the specific notion of *impurification* that he applies to cinema – involve many ways of abandoning the opposi-tions specific to modernist thought. The notion of configu-ration, initially introduced with respect to cinema, thereby compels a redisposition of the relations between the poem and its thought, an undermining of the 'evental' theory of the poem. It is significant that the first example of configuration/subject in the *Handbook of Inaesthetics* is 'tragedy', which we are shown is initiated by the event named Aeschylus and reaches its saturation point in Euripides. This poetic configuration is very clearly a con-figuration of suture: it is 'Greek tragedy' as it was given shelter by the concepts of philosophy from Schelling to Nietzsche and Heidegger; Greek tragedy as a concept of philosophy – and also as the first subject matter of modern art *qua* 'mise-en-scène'.

But the clearest example of this blurring of modernist oppositions concerns cinema and its 'impurity'. Badiou assigns to cinema a guardhouse at the frontier separating art from non-art of which I spoke. Cinema plays the role of a sort of porter/bouncer/screener. But it is also for him the specific witness of a crisis – or, in his terms, of a saturation – of the modernist separation between art and non-art. There have been, says Badiou, two great ages of cinema, a Hollywoodian representative age and an anti-narrative, anti-representative modern age; today a third age is under way in which a not-yet discernible para-digm has prescribed cinema's 'artistic value' [*artisticité*].

But this periodization is questionable, since what the simple cut between *mimesis* and anti-*mimesis* obscures is the initial anti-representative paradigm with which cinema declared itself to be an art, before being normalized by Hollywood: that of the direct presence of the Idea in the movement of bodies and images which its theoreticians borrowed from Mallarmé and dance. It might further be argued here that such clear-cut paradigms, just like that of 'grand narratives', are retrospective visions that conceal the play of opposed paradigms constitutive of the effective dynamism of twentieth-century art. What Badiou has described is simply what others would call a postmodern age of cinema (and 'postmodernism' is nothing other than the disenchanted acknowledgement of the inconsistency of the modernist paradigm with regard to the reality of aesthetic melanges). But the interesting thing here is the tacit reversal that this diagnostic requires to be enacted on the very distinction between representative and anti-representative ages, since it affirms that cinema does not obey the internal divisions of art because it is not really an art, or else is an entirely peculiar art: an impure art, or an art of impurity, the art of mixture in general, that which is made up of an admixture of other arts (the novel, music, painting, theatre). On the one hand, Badiou thus reprises one of André Bazin's theses;[36] but on the other, he radicalizes it. For Badiou, cinema not only consists of a mixture of other arts. Its specific task is exactly to *impurify* them.

The assigning to cinema of an improper 'specificity' is a very specific form of exclusion of the impure, that is to say in terms of aesthetics as a regime of art, a regime of indistinction between art and the arts. Badiou saddles an art, relegated to the border, with the burden of harbouring all the 'impurifications', all the crossings-over which – ever since Mallarmé and others established the conceptual programme – have invaded the field of the arts, blurring the

[36] André Bazin, 'Pour un cinéma impur: Défense de l'adaptation', in *Qu'est-ce que le cinéma?*, Paris: Éditions du Cerf, 1997, pp. 81–106.

boundaries between exhibitions of speech and dance or the circus, between painting and sculpture, or between photography and the art of light projections. It is indeed clear that cinematographical 'impurification' has many precursors. First, there was the opera invented as a restoration of Greek tragedy before becoming a total work of art, or going on to lend its name to 'soap opera'. Then, there were all those 'impurifications' of the dramatic arts – montages of text and of décors, boxing-rings, circus-rings, bio-mechanical and Symbolist choreography – through which theatre – under this latter name or else that of mise-en-scène – was declared an autonomous art. Many schemas of montage, play and cinematographical visuality were formed on the terrain constituted by these 'impurifications'. Badiou has to cut inside all these mixed *dispositifs* in order to relegate the impure to a place on the perimeter. He has to exclude them from the theatre so that he can turn the latter into the pure 'place' of the 'formula' and the mise-en-scène into the chance ephemeralization by which the eternal of the Idea in the text becomes a collective convocation of latent courage. He has to concentrate impurity in the domain of cinema. So, Badiou does not identify, except by pushing it immediately to the margins of art, the impurity – or confusion – constitutive of that aesthetic regime of arts by which art's singularity alone exists.

The same thing is at stake in the other function that Badiou assigns to the impure art of cinema: to expurgate what can be expurgated from non-art. The formal 'impurification' of the other arts is actually, according to Badiou, the means by which cinema expurgates its own impurity; in this vein, it expurgates all the imagery, all the stereotypes of visuality that constitute its primary matter. Thus conceived, cinema divides into two: it is art inasmuch as it expurgates the visual stereotypes which, in Guy Debord's sense, constitute it as a spectacle, which is to say as a form of image trade and of circulation of social stereotypes of visuality, such as, for instance, today's stereotypes of pornography, of speed, of catastrophe or of the virtual. By

the same token, however, cinema in general carries out an expurgation of non-art. It forms the border and point of passage, filtering out what of non-art is allowed to pass over into art.

At this point, also, Badiou runs up against a general law of the aesthetic regime of arts, but recognizes it only under the species of the cinematographical and seeks to relegate it to art's borders. What he says about cinema would apply equally well to literature – which, as a *theoretician*, Badiou identifies only under the name of the poem. Because the latter, understood in its constitutive impropriety, gave rise to an exemplary process of negotiating the indiscernible boundary – forever being retraced – between art and non-art. Regarding cinematographical impurity, Badiou himself alludes to the 'idiotic paintings' in which Rimbaud sought the gold of the new poem. But one could just as well evoke Balzac and his way of 'impurifying' the fine flow of narrative prose by importing 'impurifications' into it from painting, by extracting a story from the Netherlandish portrait genre, which as mentioned above, thanks to Hegel and a few others, played a central role in the aesthetic alliance of thought and the image. The impurifying of prose via painting, and of painting via prose, fostered, in Balzac's work, a 'purification' process which was always at the limits of the indiscernible, which reworked and rearranged the stereotypes of the novel serialized in feuilletons, but also the stereotypes of that mode of imaginary visuality illustrated by the particular *Physiologies* of his era, that presentation which society gives of itself and of the distribution of the types constituting it. Cinema's duality as art and non-art, as impurifying and expurgating, in fact recalls the long history of exchanges between art and non-art defining the aesthetic regime of art. So, even as it seeks to protect itself from the latter, Badiou's concept of inaesthetics actually seems an apt way to initiate a new dialogue with aesthetics. It impugns, if it does not undermine, the very operations which it itself had used to challenge the aesthetic regime of arts.

Inaesthetics thus shows itself to be the common name – the homonymous and equivocal name – for three processes by which Badiou's modern Platonism confronts the equivocations of art's homonymy. First, inaesthetics names the operations of concealment – the operations of dissociation from the aesthetic regime of arts – by which the 'Platonism of the multiple' is established as a form of thinking about art. It names the operations by which Badiou strives to extricate art's – i.e. the poem's – 'truths' from the indistinction of the metamorphic universe in which the aesthetic regime ties together forms of art, forms of life and forms of thinking about art. Second, inaesthetics designates the twisted necessity according to which the lines of division that cause the Platonism of truth to conceal itself from aesthetic Platonism are made to coincide with those by which modernism seeks to secure 'art's specificity' from slipping into aesthetics' indistinction, the way in which the Platonic heteronomy of art is made to fit with the modernist dogma of its autonomy. Inaesthetics, however, also seems to designate a third process, which completes and impugns the first two. It designates the movement whereby the assignation of places to art, not-yet art and to art/not-art impugns the purpose it served and releases once more that which it had locked away, again tying art to non-art and to the discourse on art. In such a way, then, inaesthetics would no longer merely amount to a translation into Badiou's terms of modernism's anti-aesthetic accomplishment. Instead it could serve as a name for a process of reworking art's 'specificity' and its homonymy. Against anti-aesthetic resentment and postmodern inanity, it might be seen as a space and time from which to challenge the modernist knot of thought on art in Badiou's work, of a reconsideration of the false evidences of the identifying of art and its homonymy.

It does not seem, however, that inaesthetics as Badiou understands it proceeds along this path. His 'Affirmationist Manifesto', which comprises a synthesis of his vision of art, reveals a Badiou more concerned to reaffirm a

'specificity of art' subject to the educative vision he confers upon it. Taking this path, inaesthetics can only run into modernism's main antinomy. This antinomy is simple to formulate: the more one emphasizes art in its specificity, the more one is led to identify that 'specificity' with the experience of radical heterogeneity, whose ultimate model is Paul's disconcerting shock-encounter with God or God's speaking to Moses in the cloud. As it says in the 'Affirmationist Manifesto', 'The art that is, and the art that is to come, should hang together as solidly as a demonstration, be as surprising as a night-time ambush, and be as elevated as a star.'[37] This formulation is by no means a simple rhetorical approximation. It points in exemplary fashion to the heart of Badiou's problematic: the double transformation of the revolutionary cut into a Lacanian encounter with the face of the Gorgon and of the Gorgon into the Platonic call of the Idea. To posit an identity between the art which is and that which ought to be, art must be made the pure experience of the imperative dictated by the sudden encounter with the Other. On this point, the assertion proper to inaesthetics of the Idea's Platonic force joins with the proclamation of the Other's commandment proper to the aesthetics of the sublime. Each of them isolates art from aesthetics, only to prostrate it before the indistinction of ethics.[38]

[37] Badiou, *Polemics*, trans. Steven Corcoran, London and New York: Verso, 2006, p. 147. (French original, 2004; an earlier version, written in a more polemical spirit, was published under the title 'Sketch of an Affirmationist Manifesto', in *Utopia 3: La Question de l'art au troisième millénaire*, ed. Ciro Giordano Bruni, Paris: Groupe d'Étude et de Recherche des Médias Symboliques, 2002).

[38] A first version of this essay was presented at the colloquium on Alain Badiou's thought held at Bordeaux in October 1999, and published in the conferences proceedings ed. Charles Raymond, *Alain Badiou: Penser le multiple*, Paris: L'Harmattan, 2002.

Lyotard and the Aesthetics of the Sublime: a Counter-reading of Kant

'For the last century, the arts have not had the beautiful as their main concern, but something which has to do with the sublime.'[39] This short sentence could be seen as summing up the argument of several essays in *L'Inhumain* devoted by Jean-François Lyotard to art, to the avant-gardes and their future. The sentence performs a radical distinction between two types of aesthetics in Kant's *Kritik der Urteilskraft*.[39a] On the one hand, there is the aesthetics of the beautiful, which allegedly holds for the classic universe of judgements of taste and the Beautiful ideal. But the emergence of a new exhibition- and salon-going public who disregarded the rules of art and principles of taste allegedly *de facto* undid all this universe's legislation, obliging Kantian critique to elaborate a few conceptual monsters (a universality without concept, a finality without end and a pleasure devoid of interest) On the other, it is maintained that an aesthetics of the sublime can account for the discrepancy between art's sensible materiality and

[39] Jean-François Lyotard, *The Inhuman*, trans. Geoffrey Bennington and Rachel Bowlby, Stanford: Stanford University Press, 1991, p. 135 (French original, 1989).
[39a] Immanuel Kant, *Critique of Judgement*, trans. James Creed Meredith, Oxford: Oxford University Press, 2007 (German original, 1790).

the law of the concept. Lyotard even maintains that this aesthetics provides a suitable basis on which to establish the proper task of the musical and pictorial avant-gardes: to bear witness to the unpresentable. He contrasts this negative task with the positivist nihilism of aesthetics as a discourse which, under the name of culture, delights in the ruined ideals of a civilization. For Lyotard, the on-going combat between the aesthetic nihilism of the beautiful and art as witness to the sublime is exemplified by the reversion, in painting, to figuration or blending figurative motifs with abstract ones, as can be seen in certain trans-avant-gardist or neo-expressionistic works.

This reference to the Kantian sublime instantly raises a problem, which can be simply stated. From Kant's viewpoint, the very idea of an art of the sublime would seem contradictory. With Kant, the sublime does not designate the products of artistic practice. Even when it is experienced while standing before Saint Peter's in Rome or the pyramids at Giza, the feeling of the sublime does not point either to the work of Michelangelo or to that of an Egyptian architect. It simply translates the incapacity of the imagination to grasp the monument as a totality. Imagination's incapacity to present a totality to reason, analogous with its feeling of powerlessness before the wild forces of nature, takes us from the domain of aesthetics to that of morality. It is a sign that recalls to reason the fact of its superior power over nature and of its legislative vocation in the supersensible order. How, then, to ground theoretically a sublime art? How to define as the characteristic of an art, by contrast, that which marks a going beyond of the domain of art, the entry into the ethical universe?

Lyotard was obviously aware of the problem. But he raised it only so as to suppress it more thoroughly. 'The sublime', he says, 'is none other than the sacrificial announcement of the ethical in the aesthetic field.'[40] And

[40] Lyotard, *The Inhuman*, p. 137.

from this he deduces the following question: 'What is an *art*, painting or music, an art and not a moral practice, in the context of such a disaster?'[41] I return to the terms 'sacrifice' and 'disaster' below. But what should initially be noted is the peculiar twist implied by this way of formulating the problem. The question that might have been expected is: does such thing as a sublime art exist? Lyotard replaces it with another: *what is the type of art* which fits within this category? What are the properties of an art of the sublime as 'art of the disaster'? The question raised is therefore an anticipated response. And this response substantializes in advance the idea of an art of the sublime.

Doubtless, there is no novelty in transforming the feeling of the sublime into a form of art. Hegel had already substantialized the Kantian sublime by turning it into a property of art. Not only did he define a sublime art but he turned the discrepancy between the idea and the faculty of sensible presentation into the very principle of what he more generally referred to as symbolic art: the art whose idea does not attain sufficient determination for it to be adequately translated into sensuous materiality. Even so, with Hegel 'sublime disagreement' remains close to its Kantian origin insofar as it involves a disagreement between the 'faculties', a disagreement concerning the idea that the artist tries to translate into words or stone. At this point the Lyotardian sublime distinguishes itself from its preceding versions. Its power, it is maintained, is that of the sensible itself. Where the art of the beautiful imposes form on matter, an art of the sublime consists in approaching matter, 'approaching presence without recourse to the means of presentation'.[42] The issue at hand, then, concerns sensuous matter in its very alterity. How to conceive that alterity? Lyotard accords it two essential traits. First, matter is *pure difference*. By this is meant a difference that is not determined by any set of conceptual determinations,

[41] Ibid., p. 137.
[42] Ibid., p. 139.

such as timbre or nuance, the singularity of which stands in contrast to the play of differences and determinations that govern musical composition or the harmony of colours. Lyotard gives this irreducible material difference an unexpected name: he calls it 'immateriality'.

This 'immaterial materiality' is not without its precedents. It recalls the grand theme that traversed artistic thought from the Symbolist age to the Futurist: that of matter turned into pure energy, akin to the immaterial power of thought; and that of the light of the Idea melded with the immaterial flash of electricity. It also recalls the phenomenological emphasis on the scintillation of the *there is*, on the invisible event of a coming-to-presence. But Lyotard's analysis has a more specific goal. It aims to transfer to the material event the properties that Kant conferred on form. Now, in Kant's *Analytik des Schoenen*, form is characterized by its unavailability.[42a] Aesthetic judgement refers to a form that is not a conceptual form imposing its unity on the diversity of sensation. The beautiful is beautiful inasmuch as it is neither an object of knowledge, subordinating sensation to the law of the understanding, nor an object of desire, subordinating reason to the anarchy of sensations. This *neither . . . nor . . .*, the unavailability of this form for the faculties of both understanding and desire, enabled the subject, through the free play of those faculties, to experience a new form of autonomy.

Lyotard claims the same status for timbre and colour. For Kant, we know, these latter presented a problem: how are we to determine whether the pleasure they procure stems from the pure sensuous pleasure produced by the vibrations on our senses or whether it depends on the formal perception of their regularity? Lyotard presents his account as a radical response to that difficulty. He quite simply claims the unavailability of aesthetic form for both

[42a] The 'Analytic of the Beautiful' is the first book of Kant's *Critique of Judgement*.

timbre and colour. This displacement might initially recall the modernist vulgate's insistence on the singularity of sensible presence as opposed to representation. Matter, then, would be nothing other than the 'grain of a skin or a piece of wood, the fragrance of an aroma, the savour of a secretion or a piece of flesh, as well as timbre or a nuance'. Yet this quickly appears not to be so. 'All these terms are interchangeable', says Lyotard, 'they all designate the event of a passion, a passibility [*un pâtir*] for which the mind will not have been prepared, which will have unsettled it, and of which it conserves only the feeling – anguish and jubilation – of an obscure debt.'[43] That is the second character of matter: not at all its singularity but its power to make passible [*faire pâtir*]. Its 'immateriality' does not reside in any particular sensible quality. It resides only in what is common to all of them: they are all 'the event of a passion'. The specific quality of timbre or nuance, of the grain of a skin or the fragrance of an aroma is not important. All that imports is their common power to throw the mind into disarray, to place it in debt.

While Lyotard borrows the first characteristic of matter, i.e. its immateriality, from the Kantian analytic of the beautiful, the second clearly comes from the analytic of the sublime. After conferring the autonomy of form on timbre and nuance, Lyotard confers on them the disruptive power of the inform, the discord specific to the experience of the sublime. The *aistheton*, then, is two things in one. It is both pure materiality and a sign. The pure passion of the sensory event is at once the sign of a reality which is thereby made known. The musical timbre or the nuance of colour play the role that Kant reserved for the pyramid and the wild ocean. They signal the mind's incapacity to grasp hold of an object. But the status of the logic of impossibility is diametrically opposed to what it is in Kant's work. For Kant, it is imagination that reveals itself to be powerless to master the form, or the exceptional

<hr>

[43] Lyotard, *The Inhuman*, p. 141.

nature, of the sensible power with which it is confronted. It is imagination that is unable to provide the representation of the whole that reason demands of it. Thereby 'the greatest faculty of sense' betrays its powerlessness to give sensible form to the Ideas of reason. In this way, however, it proves the power of reason twice over: reason can cross the limits of sensory experience *and* it can demand from the imagination what imagination itself is powerless to do. The incapacity experienced by the subject's faculty of sense attests to the presence of an 'unlimited faculty' within it.[44] The imagination thrown into disarray leads the mind to its supersensible vocation. And this revelation itself leads from the autonomy of the aesthetic free play of the faculties to a superior autonomy: the autonomy of legislative reason in the supersensible order of morality.

Lyotard turns this logic strictly on its head. The feeling of powerlessness in the experience of the sublime, is endured by reason. It experiences its inability to be able to 'approach matter', in other words to be able to master the sensible event of a dependency. What sublime experience teaches us is this: 'the soul comes into existence dependent on the sensible, thus violated, humiliated. The aesthetic condition is enslavement to the *aistheton*, without which it is anaesthesia. Either it is awakened by the astonishment of the other, or annihilated . . . the soul remains caught between the terror of its impending death and the horror of its servile existence.'[45] We must understand, however, that this sensory constraint is not the only one imposed. As with Kant, the sensory experience of the sublime is the sign of something else. It introduces the subject's relationship to the law. With Kant, the imagination's failure brings forth the autonomous law of the legislative mind. With Lyotard, the logic is strictly inverted:

[44] Kant, *Critique of Judgement*.
[45] Lyotard, *Postmodern Fables*, trans. Georges Van Den Abbeele, Minneapolis: University of Minnesota Press, 1997, 243–4 (French original, 1993).

subordination to the *aistheton* signifies subordination to the law of alterity. Sensory passion is the experience of a 'debt'. Ethical experience is that of a subordination without appeal to the law of an Other. It manifests thought's servitude with regard to a power internal and anterior to the mind that it strives in vain to master.

It would be pointless to conclude that Lyotard misread or misunderstood Kant. It is no doubt more judicious to ask why he read him in the way that he did. But the first question to ask is simply this: why does he need Kant? Why go and seek in Kant's texts things that in all likelihood are not to be found in them, i.e. a theory of the artistic avant-garde, the ascription of a task for this avant-garde that consists in its attesting the subject's misery, and an idea of the moral law as a law of heteronomy? Such is, indeed, the paradox posed by the Lyotardian theory of the sublime. This theory is offered as a continuation of modernist tradition, insofar as it saddles the avant-garde with the task of safeguarding artistic novelty against forms of reversion to outmoded expressions and compromises with commercial aestheticization. For the Lyotard of the 1980s then, what defined the task of the avant-gardes was the refusal of eclecticism – that manifest in the new pictorial tendencies in which painters mixed both figurative and abstract motifs on their canvases. However, his renewing of the avant-garde task is grounded in a notion of art as that which testifies to the immemorial dependency of the human mind on the unmasterable presence that, following Lacan, he calls the 'Thing'.

How are we to think of this paradoxical conjunction between an artistic revolution, whose forward march proscribes returning to old forms, and art's assigned duty to testify to an insuperable and immemorial servitude? To understand the logic behind this, we have to examine Lyotard's argument against what he saw as a shameless mixture of abstract and figurative motifs in pictorial form, *viz.* trans-avant-gardism:

Mixing on the same surface neo- or hyper-realist
motifs with abstract, lyrical or conceptual motifs means
that everything is equivalent because everything is
good for consumption. This is an attempt to establish
and have approved a new 'taste'. This taste is no
taste. What are called upon by eclecticism are the habits
of magazine readers, the needs of the consumer of
standard industrial images – this is the spirit of the
supermarket shopper. To the extent that this postmod-
ernism, via critics, museum and gallery directors and
collectors, puts strong pressure on the artists, it consists
in aligning research in painting with a *de facto* state
of 'culture' and in deresponsibilizing the artists with
respect to the question of the unpresentable. Now in
my view this question is the only one worthy of
what is at stake in life and thought in the coming
century.[46]

What makes it possible to determine that such a taste is in
fact *not* really one? Lyotard's response is as follows: if it
is a taste, art's historical duty and the proper task for our
thinking for the century to come is lost to us. In short, it
is not a taste because it *ought* not to be one. The form of
the argument is easily recognizable and comes straight
from Adorno. Lyotard's polemic against pictorial eclec-
ticism is an exact reprise of Adorno's polemic against
musical eclecticism. His phrases echo those that the
Philosophie der neuen Musik (1949) devotes to the dimin-
ished-seventh chords that musically trained ears can no
longer stand, not 'unless everything is only deception'. In
declaring that it is impossible to meld the abstract with the
figurative in painting, Lyotard upholds the tradition of
that Marxism which, notably in Adorno or Clement
Greenberg, tied art in its radical autonomy to the promise
of social and political emancipation. We have seen how
this tradition has always defended, against the conven-
tional oppositions between art for art's sake and engaged

[46] Lyotard, *The Inhuman*, p. 127.

art, a different idea of art's politicity: namely that art is political provided that it *is* art. And an art is only such if it produces objects that, both in texture and the way we experience them, have a radically different status to the objects of consumption.

The recourse to Kant served precisely to think through this difference in status with respect to the sensible. Kant maintained that the beautiful must be separated from the good, which arises as much from the concept as from the agreeable, which pertains to sensation. Both Adorno and Lyotard claim, in their turn, that artworks ought not to be pleasurable. They ought to be unavailable to the desire that addresses itself to objects of consumption. Indeed it is owing to this very unavailability that they produce a specific good. Art is a practice of dissensus. And it is by means of this dissensus, and not by enlisting in a cause, that artworks receive their specific quality and get linked to an external good: future emancipation (Adorno) or the response to a demand prescribed by the century (Lyotard).

But between Adorno and Lyotard an inversion takes place. Adorno calls the dissensus 'contradiction'. Internal contradiction is what generates the opposition between artistic productions and the eclecticism that governs commercial aesthetics. It bestows upon the work a twofold property, a power and a lack of power: a power of self-sufficiency, which contrasts with commercial heteronomy; and a lack of power, an insufficiency which prevents it from being complacent in that self-sufficiency and has it testify to the constitutive alienation that separates labour from enjoyment. With Lyotard, too, art's task still consists in constituting a specific sensible world, separate from that governed by the law of the market. But the dissensus involved here is no longer called contradiction. Its name is now 'disaster' and the disaster is 'original': it testifies to an alienation that no longer has anything to do with the capitalist separation of pleasure and enjoyment, but is the simple destiny of dependency proper to the human animal.

And the avant-garde's sole responsibility is to bear the memory of it indefinitely.

This enables us to grasp the logic of Lyotard's counter-reading, which turns the Kantian sublime into the joint principle of the artistic avant-garde and the ethical law of heteronomy. But in order to understand its meaning fully, it is necessary to reconstitute the chain of interpretations of which it is the last link. We, in turn, need to read it as a sort of palimpsest which, in order to efface a first reading of Kant, also effaces the inherent 'politics' of his work. The argument according to which art's assigned task consists in registering the shock of the *aistheton*, and to which this shock is the indelible testimony of a 'servile condition', is thus the outcome of a precise inversion of the new promise of freedom that Schiller saw in the suspension of the 'aesthetic state'. The core argument of the *Letters on the Aesthetic Education of Man* resides in the same double negation that characterizes Kantian aesthetic negation. It states that the latter is subject neither to the law of understanding, which requires conceptual determination, nor to the law of sensation, which demands an object of desire. Aesthetic experience suspends both laws at the same time. It therefore suspends the power relations which usually structure the experience of the knowing, acting and desiring subject. This means that, for Schiller, the 'agreement' of faculties in aesthetic experience is not the old harmony of form and matter that Lyotard claims it to be. It is, on the contrary, a break with this old agreement, which is really a form of domination. In itself, the 'free agreement' between understanding and the imagination is already in itself a disagreement or dissensus. It is not necessary to go looking in the sublime experience of size, power or fear to discern a disagreement between thought and the sensible or to ground modern art's radicality in the play of attraction and repulsion. The experience of beauty, which is apprehended by Kantian aesthetic judgement in terms of a *neither. . . nor . . .* , is already characterized by the double bind of attraction and repulsion. It consists in a tension

between two opposed terms, namely a charm that attracts us and a respect that makes us recoil. The statue's free appearance, says Schiller, simultaneously draws us in with its charm and keeps us at a distance through the sheer majesty of its self-sufficiency. This movement of contrary forces at the same time puts us in a state of utter repose and one of supreme agitation.[47] There is, then, no rupture between an aesthetics of the beautiful and an aesthetics of the sublime. Dissensus, i.e. the rupture of a certain agreement between thought and the sensible, already lies at the core of aesthetic agreement and repose.

This identity between agreement and disagreement is what enabled Schiller to confer on the 'aesthetic state' a political signification over and above the simple promise of social mediation implied by Kantian common sense, which hoped to unite the elite's sense of refinement with ordinary people's natural simplicity.[48] Aesthetic common sense, for Schiller, is a dissensual common sense. It does not remain content with bringing distant classes together. It challenges the distribution of the sensible that enforces their distance. Why does the statue of the goddess attract and repel us at one and the same time? Because it manifests that character of divinity which is also, says Schiller, that of humanity in its fullness: she does not work, she plays. She neither yields nor resists. She is as free of the ties of commandment as she is of those of obedience. Yet this state of harmony stands in contrast to the state that governs human societies and puts each person in his place by separating those who command from those who obey, men of leisure from working men, men of refined culture from those of simple nature. The dissensual common sense of aesthetic experience is as opposed to the consensus of traditional order as to that which the French Revolution tried to impose. The Revolution wanted to overturn the *ancien* order of domination. However, it itself reproduced

[47] Schiller, *Letters on the Aesthetic Education of Man*, p. 109.
[48] Kant, *Critique of Judgement*, p. 183.

the *ancien* logic according to which an active intelligence comes to impose itself on a passive materiality. The suspension of power, the *neither . . . nor . . .* specific to the aesthetic state, by contrast, announces a wholly new revolution: a revolution in the forms of sensory existence, instead of a simple upheaval of the forms of state; a revolution that is no mere displacement of powers, but a neutralization of the very forms by which power is exercised, overturning other powers and having themselves overturned. Aesthetic free play – or neutralization – defines a novel mode of experience that bears within it a new form of 'sensible' universality and equality.

The tension animating both Adorno's aesthetics and the Lyotardian anti-aesthetics of the sublime becomes fully intelligible only when referred to a primitive scene, one that serves to ground both art's autonomy and the promise of an emancipated humanity in the experience of a sensorium of exception, where the activity/passivity and form/matter oppositions governing the other forms of sensory experience are cancelled out. This tension has to be understood in continuity with the double bind that Schiller placed at the very centre of the harmony of the faculties in its Kantian sense. The reason is that this double bind enables the mediation specific to Kantian common sense to be turned into the positive principle of a new form of existence. Thanks to this double bind, aesthetic 'free play' ceases to be a mere intermediary between high culture and simple nature, or a stage of the moral subject's self-discovery. Instead, it becomes the principle of a new freedom, capable of surpassing the antinomies of political liberty. In a nutshell, it becomes the principle of a politics or, more exactly, of a metapolitics, which, against the upheavals of state forms, proposes a revolution of the forms of the lived sensory world.

The contradiction at the heart of Adornian aesthetics and the 'disaster' announced in Lyotardian aesthetics ought precisely to be understood as avatars of that aesthetical metapolitics. They are the final forms taken by the original tension inherent in the very idea of 'the aesthetic education of man': a tension between the suspension of activity

specific to the aesthetic state and the activity of self-education that is designed to fulfil its promise, between the *alterity* of that experience and the *selfness* or *thisness* of the education; or again, between the *self-sufficiency* of free appearance and the movement of self-emancipation of a new humanity which desires to tear the appearance from its self-sufficiency and turn it into a reality. The Schillerian primitive scene already contains the contradiction. The alterity of the statue's self-sufficient block of stone promises the contrary of what it is. To a humanity rent by the division of labour, occupations and ranks, it promises a community to come that no longer has to endure the alterity of aesthetic experience, but in which art's forms will again be what they once were – or what they are said to have been: the forms of an unseparated collective life. Encountered within aesthetic experience, the other is no more than a self separated from itself. The alterity, or heterogeneity, which underpinned the autonomy of that experience is thereby effaced and a new alternative emerges. The *neither . . . nor . . .* of dissensual common sense becomes an *either . . . or . . .*: either the everlastingness of a human subject rent in two, or the restoration of its integrity; either the subject which passively contemplates the representation of that lost integrity in the lifeless marble, or the activity which seeks to reappropriate it in real life, thereby constructing a new lived world, wherein, as Malevich put it, projects of collective life take the place of 'old Greek ladies'. Either dissensus is reduced to the conflict between appearance and reality, or a new consensus is formed for the purpose of transforming the appearances of art into the realities of common life, in other words of transforming the world into the product and mirror of human activity.

To restore the aesthetic double bind will thus be made the atomic project of this counter-Marxism, of the alternative form of aesthetic politics governing Adorno's aesthetics, and which Lyotard's aesthetics stands on its head. The principle of this counter-movement can be summed up in two basic points. First, to restore aesthetic *separation* or

aesthetic strangeness as that which alone can carry the promise of a new sensible world. If the most resolute champions of art's autonomy have often been Marxists, it is not due to any spirit of conciliation or any inner conflict between a love of art and the demands of social emancipation. A broad-minded Marxism did not set out to counter dogmatic Marxism. Instead, an opposition took shape between two forms of aesthetic metapolitics. In this opposition the promise of emancipation came to be linked with the sensible heterogeneity of aesthetic form. This heterogeneity entails revoking the power of intellectual form over passive sensible matter that tied the productions and ideals of the representative arts to the order of domination. That is what is contained in the *neither . . . nor . . .* of aesthetics: certainly not the purity of art but instead the purity of the gap that aesthetic experience establishes with respect to the games of power and forms of domination. The point is not to contrast artistic autonomy with political heteronomy. A form of autonomy is always at the same time a form of heteronomy. The arts of *mimesis* had their autonomy within the order that united their boundaries and their hierarchies with the order of domination. Art of the aesthetic age, conversely, declares its heterogeneity to the forms of experience of domination. But it does so by abolishing the boundaries that distinguished art objects from other objects in the world. An opposition thereby forms between two sorts of linking of autonomy and heteronomy. Aesthetic autonomy is that of an art where there is no border separating the gesture of the painter devoted to high art from the performances of the acrobat devoted to amusing the people, none separating the musician who creates a purely musical language from the engineer devoted to rationalizing the Fordist assembly line. If the metapolitics of life-art disappears in the simple statist formula 'the Soviets plus electricity', the metapolitical alternative to sustaining this alterity can, itself, be captured in the expression 'dodecaphonism plus the Tramp's bamboo cane': the purity of a musical language with no

reference to anything other than its own laws and the promotion of the entertainer in high art; musical materials subject to a discipline more rigorous than that of the Fordist assembly line and a parading vagabond clown whose automatized acts express a sentimental and 'backward-looking' refusal of mechanized life.

Schoenberg and the Tramp: the clown with his trip-up bamboo cane dragging his way through the well-ordered twelve-note scale. The formula that might be used to sum up the long and complex analyses of *Äesthetische Theorie* also epitomizes the second major feature specific to this counter-aesthetics.[48a] In it, the double bind of aesthetic experience becomes the work's own internal contradiction. The Schillerian double movement of attraction and repulsion – of 'grace' and 'dignity' – becomes the natural tendency of the work itself. The reason for this is simple. Adorno shares the same central preoccupation as Schiller: to revoke the division of labour implying the separation of labour and enjoyment, of the men of necessity and the men of culture. The work, for him, continues to promise what in the supreme state of agitation and repose was promised by the free appearance of the Greek statue: a world in which the separation of labour and enjoyment, symbolized by the primitive scene of Western reason, is abolished – namely, that in which sailors sit on their benches with their ears blocked to the songs of sirens, while Ulysses, tied to the mast and enjoying this song in itself, is unable to ask his subordinates to untie him so that he can go and meet his enchantresses. But if the work promises this reconciliation, it is only through an effort of indefinite deferral, achieved by rejecting all the forms of conciliation in which domination is allegedly still preserved in concealment. If the work is promise, it is not because its self-sufficiency contains the secret of a form of

[48a] Theodor Adorno, *Aesthetic Theory*, ed. Gretel Adorno and Rolf Tiedemann, trans. Robert Hullot-Kentor, Minneapolis: University of Minnesota Press, 1997 (German original, 1970).

life that is *one*. On the contrary, it is because it is itself divided, because its self-sufficiency is obliged to replay indefinitely the primitive scene of the line separating the calculating master tied to his mast and the sirens denied their audience. The path towards emancipation is the one that exacerbates the separation, that offers the beautiful appearance only at the price of dissonance and indefinitely reaffirms the good of dissensus by rejecting all forms of reconciliation between the beautiful and pleasure. The aesthetic scene, properly speaking, thus turns out to be the scene of the irreconcilable.

This irreconcilable is that which the Lyotardian reading pushes to the point where its affirmation becomes both the final accomplishment and the total overturning of aesthetic metapolitics. This overturning most certainly cannot be grasped within the category of 'postmodernism'. In Lyotard's work, the postmodern was never used as a sort of artistic or theoretical flag; at the very most it served as a descriptive category and as a diagnostic. And this diagnostic had an essential function: to extricate artistic modernism from political emancipation, to disconnect it in order to connect it with another historical narrative. The famous repudiation of the 'grand narrative' and the 'absolute victim' by no means gives way to the multiple universe of small narratives, dear to tender multi-cultural souls. It amounts to no more than a pure and simple change of 'grand narrative' and 'absolute victim', according to which the West's modern history is identified not with the emancipation of the proletarians but with the programmed extermination of the Jews.

Lyotard still convokes the avant-garde, summoning it to trace the line separating the production of art from the objects, images and amusements of commerce. But art's 'autonomy' in this instance is no longer that of the scene of a contradiction testifying to an alienation to be eliminated. What the artist produces is no longer the game of a contradiction; it is the inscription of a shock. The shock is still an alienation of sorts but it is an insurmountable one. The

double bind is no longer part of the work. Instead, it is the mark of a condition, that of the being that is subject to the condition of the sensible: either submission to the *aistheton* which does violence to us, or an absence of *aistheton*, which is to say death. If art is to separate itself from commerce, it is simply in order to oppose the offers and promises of commodity consumption to the original 'misery' of the mind in its subjection to the law of the Other. It is in order to testify to an alienation that cannot be eased, a sort of alienation in relation to which every will to emancipation flips over into the illusion of a will to mastery, waking us from a sleep-filled life of consumption, only to throw us headlong into the fatal utopias of totalitarianism.

Lyotard's counter-reading of Kant is therefore most certainly an attempt to efface a first political reading of aesthetic experience. What it strives to do is to efface the original link between aesthetic suspension and the promise of emancipation. It strives to convert, once and for all, the *neither . . . nor . . .* into an *either. . . or. . . .* At the point where Schiller marked the exception of a form of sensory experience, conversely, it has us read the simple testimony to a common condition. Instead of a suspension of forms of mastery, it has us read our enslavement to an imperious master. Schiller contrasted the promises of emancipation contained in the double bind of aesthetics to the cut of the revolutionary expression 'Freedom or death'. Lyotard transforms the cut of this double bind again by inverting its form: 'Servitude or death'. Basing himself on Kant, Schiller endeavoured to elaborate a third way between the eternity of domination and the savagery of rebellion. He reprised Kant's idea according to which aesthetic experience points to something else: respectively rational legislation or a new form of sensible community. Lyotard retains the function of the sign, but only in order to invert it. Aesthetic experience becomes that of the enslaved human mind, the mind enslaved to the sensory, but also, and above all, enslaved, on account of this sensory dependency, to the law of the Other. The shock of the sensuous exception that in Kant

was a sign of freedom, and in Schiller a promise of emanci-
pation, in Lyotard signifies exactly the opposite, namely a
sign of dependency. It marks the fact that there is nothing
to be done except obey the immemorial law of alienation.
If the avant-garde is called upon to retrace indefinitely the
line of separation, it is in order to dismiss the maleficent
dream of emancipation. This enables the meaning of aes-
thetic dissensus to be reformulated as either a disaster, or
else a different disaster: either the 'disaster' of the sublime,
which is the 'sacrificial' pronouncement of ethical depend-
ency with respect to the immemorial law of the Other; or
the disaster that is born of the forgetting of that disaster,
the disaster of the promise of emancipation that can only
lead either to the overt barbarism of Nazi and Soviet
camps, or to the soft totalitarianism of the world of com-
mercial culture and communication.

So, art still finds itself inscribed in the metapolitical sce-
nario. But the meaning of this scenario is turned entirely
upside down. Art no longer carries any promise. It is still
seen as a form of 'resistance', in memory of Adorno. But
this term takes on a wholly new meaning. Resistance
becomes nothing other than the anamnesis of the 'Thing',
the indefinite re-inscription, in written lines, painted brush-
strokes or musical timbres, of subjugation to the law of the
Other. Either obedience to the law of the Other that does us
violence, or indulgence in the law of the *self* that leads us
into an enslavement by commercial culture. Either the law
of Moses or that of McDonald's, such is the last word that
an aesthetics of the sublime contributes to an aesthetic
metapolitics. It is not certain that this new law of Moses
really is so opposed to that of McDonald's. What is certain,
on the other hand, is that by promoting the unique law that
today goes by the name of ethics, it accomplishes a joint
suppression of both aesthetics and politics.[49]

[49] A first version of this chapter was given in English at a colloquium
called *Kant's Critique of Judgement and Political Thinking*, held at
Northwestern University, Evanston, Illinois, in March 2002.

The Ethical Turn of
Aesthetics and Politics

The Ethical Turn of Aesthetics and Politics

In order to understand exactly what is at stake in the ethical turn that is impacting aesthetics and politics today, we must precisely define what is meant by the word 'ethics'. Ethics is no doubt a fashionable word. But it is often taken for a simple, more euphonious translation of the old word 'morals'. It is viewed as a general instance of normativity enabling one to judge the validity of practices and discourses operative in distinct spheres of judgement and action. Understood in this way, the ethical turn would mean that today there is an increasing tendency to submit politics and art to moral judgements about the validity of their principles and the consequences of their practices. Not a few people loudly rejoice about such a return to ethical values.

I do not believe that there is much cause for rejoicing, because I do not believe that this is actually what is happening. The reign of ethics is not the reign of moral judgements over the operations of art or of political action. On the contrary, it signifies the constitution of an indistinct sphere in which not only is the specificity of political and artistic practices dissolved, but so also is that which formed the very core of 'old morality': the distinction between fact and law, between what is and what ought to be. Ethics

amounts to the dissolution of norm into fact: in other words, the subsumption of all forms of discourse and practice beneath the same indistinct point of view. Before signifying a norm or morality, the word *ethos* signifies two things: both the dwelling and the way of being, or lifestyle, that corresponds to this dwelling. Ethics, then, is the kind of thinking in which an identity is established between an environment, a way of being and a principle of action. The contemporary ethical turn is the specific conjunction of these two phenomena. On the one hand, the instance of judgement, which evaluates and decides, finds itself humbled by the compelling power of the law. On the other, the radicality of this law, which leaves no alternative, equates to the simple constraint of an order of things. The growing indistinction between fact and law gives way to an unprecedented dramaturgy of infinite evil, justice and reparation.

Two films depicting the avatars of justice in a local community, both released in 2002, can help us to understand this paradox. The first is *Dogville* by Lars von Trier. The film tells us the story of Grace, the foreigner who, in order to be accepted by the citizens of this small town, places herself in their service, submitting herself at first to exploitation, followed by persecution when she tries to escape them. This story transposes Brecht's *Die heilige Johanna der Schlachthöfer*, a play in which Saint Joan is portrayed as one who wanted to instil Christian morality in the capitalist jungle.[49a] But the transposition is a good illustration of the gap between the two eras. The setting of the Brechtian fable was such that all notions were divided in two. It turned out that Christian morality was ineffective in the fight against the violence of the economic order. It had thus to be transformed into a

[49a] Brecht's *Saint Joan of the Stockyards* (German original, 1929–31), written under the impact of the Wall Street crash, the brutal repression of workers' demonstrations and the onset of the Great Depression, is set amid the slaughterhouses, workers' quarters and stock exchange of a mythical Chicago.

militant morality that took as its criterion the necessities of the struggle against oppression. The rights of the oppressed were thus held up against the right that was party to oppression and defended by strike-busting policemen. The opposition between two types of violence was therefore also that between two sorts of morals and of rights.

This dividing of violence, morality and right has a name. It is called politics. Politics is not, as is often said, the opposite of morals. It is its dividing. Brecht wrote his play about Saint Joan as a fable about politics that demonstrated the impossibility of mediating between these two sorts of rights and these two types of violence. The evil that Grace encounters in *Dogville*, by contrast, refers to no other cause but itself. Grace no longer represents the good soul mystified by her ignorance of the causes of evil. She is merely the stranger, the 'excluded' who wants to be admitted into the community, which brings her to subjugation before expelling her. This tale of suffering and disillusionment does not stem from any system of domination that might be understood and abolished. It is based upon a form of evil that is the cause and effect of its own reproduction. This is why the only fitting retribution against that community can be its radical annihilation, carried out by a Lord and Father who is none other than the king of thugs. The Brechtian lesson was: 'Only violence helps where violence reigns.' The transformed formula appropriate to our consensual and humanitarian times is: 'Only evil repays evil.' Let us translate it into the language of George W. Bush: infinite justice is the only suitable justice for the fight against the axis of evil.

The expression 'infinite justice' raised the hackles of many people and it was deemed preferable to have it promptly withdrawn from circulation. It was said to have been badly chosen. But perhaps the choice was only too fitting. In all likelihood, it is for this same reason that the morality portrayed in *Dogville* caused such a scandal. The jury at the Cannes Film Festival reproached it for its lack

of humanism, a lack that doubtless resides in the idea that where there is injustice, justice can be enforced. A humanist fiction, in this sense, would have to be a fiction that eliminates such justice by effacing the very opposition between the just and the unjust. Exactly this proposal was made by the second film, Clint Eastwood's *Mystic River* in which Jimmy commits a crime: the summary execution of his former mate Dave, whom he thinks guilty of murdering his daughter; this has gone unpunished and remains the shared secret of the guilty party and his accomplice, the policeman Sean. Why? Because the guilt that Jimmy and Sean share exceeds anything that could be judged in a court of law. For it was they who, when they were children, were responsible for dragging Dave off along on their reckless street games. It is because of them that Dave was hauled away by men posing as police, locked up and raped. Dave's trauma then made him a problem adult whose aberrant behaviour singled him out as the ideal culprit for the young girl's murder.

Dogville is a transposition of a theatrical and political fable. *Mystic River* is a transformation of a cinematographic and moral fable, the scenario of which had been depicted notably in films by Alfred Hitchcock and Fritz Lang: that of the falsely accused.[50] In this scenario, truth is put to work against the fallible justice of courtrooms and public opinion, and always ends up winning out, sometimes at the cost of confronting another form of fate. But today, evil, with its innocent and guilty parties, has been turned into the trauma which knows of neither innocence nor guilt, which lies in a zone of indistinction between guilt and innocence, between psychic disturbance and social unrest. It is within such traumatic violence that Jimmy kills Dave, who is himself the victim of a trauma resulting from a rape whose perpetrators were probably also victims of some other trauma. However, not only is

[50] Alfred Hitchcock, *The Wrong Man* (1957); Fritz Lang, *Fury* (1936) and *You Only Live Once* (1937).

a scenario of disturbance and sickness used to replace one of justice. The sickness itself has changed its meaning. The new psychoanalytical fiction stands in stark contrast to the one that Hitchcock and Lang drew on in the 1940s, in which reactivating a buried childhood memory worked to save the violent or the sick.[51] Childhood trauma has become the trauma of being born, the simple misfortune that befalls every human being for being an animal born too early. This misfortune, from which nobody can escape, dismisses the very notion that injustice could be dealt with by enforcing justice. It does not do away with punishment. But it does eliminate the justice of punishment. It reduces punishment to the imperatives of protecting the social body, not without the usual few blunders. Infinite justice then takes on its 'humanist' shape as the necessary violence required to exorcise trauma in order to maintain the order of the community.

Many people jump at denouncing the simplistic nature of the psychoanalytical scenarios in Hollywood films. These scenarios, however, turn out to have adapted their structure and tonality rather faithfully to the lessons of learned psychoanalysis. From Lang's and Hitchcock's depictions of successful cures to Clint Eastwood's presentation of the buried secret and irreconcilable trauma, it is easy to recognize the shift from the intrigue of Oedipal knowledge to the irreducible division of knowledge and law symbolized by another great literary figure, namely the tragic heroine Antigone. Under Oedipus' sign, trauma amounted to a forgotten event that could be cured when the trauma was reactivated. When Antigone comes to replace Oedipus in Lacanian theorization, a new form of secret is established, one that is irreducible to any salvational knowledge. There is neither beginning nor end to the trauma encapsulated in *Antigone*. The tragedy bespeaks the discontent of a civilization in which the laws of social

[51] Hitchcock, *The House of Dr Edwards* (1945); Lang, *The Secret Behind the Door* (1948).

order are undermined by the very things that support them: the powers of filiation, earth and night.

Antigone, said Lacan, is not the heroine of human rights created by modern democratic piety. Instead, she is the terrorist, the witness of the secret terror that underlies the social order. Terror is precisely the name that trauma takes in political matters and is one of the catchwords of our time. The word unquestionably designates a reality of crime and horror that nobody can afford to ignore. But it is also a term that throws things into a state of indistinction. Terror designates not only the attacks in New York on 11 September 2001 or in Madrid on 11 March 2004, but also the strategy in which these attacks are inscribed. Little by little, however, the word terror has also come to designate not only the shock these events caused in people's minds, but also the fear that similar events might recur, possibly leading to further acts of inconceivable violence, and the situation characterized by the management of such fears by state apparatuses. To talk of a war against terror is to connect the form of these attacks to the intimate angst that can inhabit each one of us in the same chain. War against terror and infinite justice then fall into a state of indistinction, occasioned by a preventative justice which attacks anything that is sure, or at least likely, to trigger terror, anything that threatens the social bond holding the community together. The logic of this form of justice is to stop only once the terror itself has stopped, but this is a terror which by definition never stops for beings who must endure the trauma of birth. At the same time, therefore, this is a kind of justice for which no other kind of justice might serve as a norm – it is a kind of justice that places itself above the rule of law.

Grace's misfortunes and Dave's execution nicely illustrate this transformation of the interpretative schemes of our experience which I call the ethical turn. The essential feature of this process is certainly not the virtuous return to the norms of morality. It is, on the contrary, the suppression of the division that the very word morals used to imply. Morality implied the separation of law and fact. By

the same token it also implied the division of different
forms of morality and of rights, the division between ways
of opposing right to fact. The suppression of this division
has been given a privileged name: it is called consensus.
Consensus is also a catchword of our time. However, there
is a tendency to minimize its meaning. Some reduce it to
a global agreement between government and opposition
parties over key national interests. Others see it, more
broadly, as a new style of government that gives priority
to discussion and negotiation in conflict resolution. Yet
consensus means much more than that: properly under-
stood, it defines a mode of symbolic structuration of the
community that evacuates the political core constituting
it, namely dissensus. A *political* community is in effect a
community that is structurally divided, not between diver-
gent interest groups and opinions, but divided in relation
to itself. A political 'people' is never the same thing as the
sum of a population. It is always a form of supplementary
symbolization in relation to any counting of the popula-
tion and its parts. And this form of symbolization is always
a litigious one. The classical form of political conflict
opposes several 'peoples' in one: the people inscribed in
the existing forms of the law and the constitution; the
people embodied in the State; the one ignored by this law
or whose right the State does not recognize; and the one
that makes its claims in the name of another right that is
yet to be inscribed in facts. Consensus is the reduction of
these various 'peoples' into a single people identical with
the count of a population and its parts, of the interests of
a global community and its parts.

Insofar as it strives to reduce the people to the popula-
tion, consensus in fact strives to reduce right to fact. It
incessantly works to fill in all these intervals between right
and fact through which the right and the people are divided.
The political community thus tends to be transformed into
an *ethical* community, into a community that gathers
together a single people in which everyone is supposed to
be counted. Only this procedure of counting comes up
against that problematic remainder that it terms 'the

excluded'. However, it is crucial to note that this term itself is not univocal. The excluded can mean two very different things. In the political community, the excluded is a conflictual actor, an actor who includes himself as a supplementary political subject, carrying a right not yet recognized or witnessing an injustice in the existing state of right. But in the ethical community, this supplement is no longer supposed to arise, since everyone is included. As a result, there is no status for the excluded in the structuration of the community. On the one hand, the excluded is merely the one who accidentally falls outside the great equality of all – the sick, the retarded or the forsaken to whom the community must extend a hand in order to re-establish the 'social bond'. On the other, the excluded becomes the radical other, the one who is separated from the community for the mere fact of being alien to it, of not sharing the identity that binds each to all, and of threatening the community in each of us. The depoliticized national community, then, is set up just like the small society in *Dogville* – through the duplicity that at once fosters social services in the community and involves the absolute rejection of the other.

To this new figure of the national community there corresponds a new international landscape, in which ethics establishes its reign first in the form of the humanitarian and then in that of infinite justice against the axis of evil. It accomplishes this through a similar process of increasing indistinction between fact and right. On national stages, this process signifies the disappearance of the intervals between right and fact in which dissensus and political subjects were constituted. On the international stage, this process translates into the disappearance of right itself, its most visible expressions being targeted assassination and the right to intervene. But this disappearance occurred by way of a detour, involving the constitution of a right above all other rights – the absolute right of the victim. The constitution of this right itself rather significantly involves overturning the meta-juridical foundation, or – as it were – the right of right, namely human rights. Since the late

twentieth century human rights have undergone a strange transformation. Long victim to the Marxist suspicion of being 'formal' rights, they were rejuvenated in the 1980s by the dissident movements of Eastern Europe. At the onset of the 1990s, the Soviet system collapsed and this appeared to pave the way for a world in which these rights, as the ostensible basis for new national consensuses, could also serve as a basis for a new international order. The explosion of new ethnic conflicts and wars of religion of course immediately belied this optimistic vision. Human rights, having been the weapon of dissidents who used them to contrast one people with that which their governments professed to incarnate, then became the rights of the victimized populations of new ethnic wars, individuals driven from their destroyed homes, raped women and massacred men. These rights thus became specific to people who were unable to exercise them. As a result, the following alternative arose: either these human rights no longer amount to anything, or else they are the absolute rights of those without rights, in other words rights demanding an equally absolute response, one beyond all formal, juridical norms.

The absolute right of those without rights can of course be exercised only by another party. This transfer was at first known as humanitarian right/interference. Then, however, the humanitarian war against the oppressor of human rights became an infinite justice to be wielded against the invisible and omnipresent enemy that terrorized those defenders of the absolute right of victims on their own territory. That absolute right then became identified with the direct demand to protect the security of a factual community. This enabled humanitarian war to be turned into an endless war on terror: a war that is not a war but instead a mechanism of infinite protection, a way of dealing with a trauma elevated to the status of a civilizational phenomenon.

We are no longer, then, in the classical framework of the discussion on means and ends. This distinction col-

lapses into the same state of indistinction as that between fact and right, or cause and effect. What is opposed to the evil of terror is, then, either a lesser evil, the simple conservation of what is, or the waiting for salvation to emerge out of the very radicalization of catastrophe.

This reversal in political thinking has taken two major forms that have lodged themselves at the very core of philosophical thinking: on the one hand, that of an affirmation of the rights of the Other, serving to provide a philosophical justification for the rights of peace-keeping forces; and on the other, that of an affirmation of a state of exception which renders politics and right inoperative, but leaves open the hope that some kind of messianic salvation will arise from out of the depths of despair. The first position was well captured by Lyotard in his essay 'The Other's Rights'.[52] Published in 1993, this was prepared in response to a question raised by Amnesty International: what happens to human rights in the context of humanitarian intervention? Lyotard defined the 'other's rights' in a way that is revealing of the meaning of ethics and the ethical turn. As he put it, human rights cannot be the rights of the human as human, the rights of the bare human being. The core of his argument is not new. It fuelled the successive critiques of Burke, Marx and Arendt. They all argued that the bare, apolitical human has no rights, since in order to have rights one needs to be 'other' than a mere 'human'. 'Citizen' is the historical name for this 'other than human'. Historically, the couple of the human and the citizen has informed two things: first, the critique of the duplicitousness of these rights, which are always elsewhere than in their place; and second, the political action that sets up different forms of dissensus in the gap between the human and the citizen.

[52] Lyotard, 'The Other's Rights', in *On Human Rights: The Oxford Amnesty Lectures*, ed. Stephen Shute and Susan Hurley, New York: Basic Books, 1993, pp. 136–47.

But in these times of consensus and humanitarian action, this 'other than human' undergoes a radical mutation. No longer does the citizen complement the human, but instead the inhuman as that which separates the human from itself. The declared inhumanity of human rights violations are, for Lyotard, actually the consequences of misrecognizing another 'inhuman', we might say, a 'positive' inhuman. Here the 'inhuman' is the part of ourselves over which we have no control, a part that takes several figures and several names. It may be childhood dependency, the law of the unconscious, or the relation of obedience to an absolute Other. The 'inhuman' is that radical dependency of the human on an absolutely other which cannot be mastered. The 'right of the other', then, is the right to bear witness to our subjection to the law of the Other. The will to master the 'unmasterable' is, according to Lyotard, where the violation of this right begins. That will is purportedly harboured by Enlightenment thinkers and is manifest in the Revolution. That will is what the Nazi genocide is supposed to have accomplished by exterminating the very people whose vocation is to bear witness to the necessary dependency on the law of the Other. And that will is purportedly also at work today in soft forms in societies of generalized consumption and transparency.

So, there are two features that characterize the ethical turn. The first is a reversal of the flow of time: the time turned towards an end to be accomplished – progress, emancipation, or the other – is replaced by that turned towards the catastrophe behind us. But it is also a levelling out of the very forms of that catastrophe. The extermination of European Jews, then, appears as the explicit form of a global situation, characteristic of the everyday existence of our democratic and liberal lives. This is what Giorgio Agamben formulates in saying that the camp is the *nomos* of modernity, its place and its rule, a rule that itself is identical with radical exception. Agamben's perspective is certainly different from that of Lyotard.

Agamben does not establish any right of the Other. On the contrary, he denounces the generalization of the state of exception and appeals to a sense of messianic waiting for salvation to emerge from the depths of catastrophe. His analysis, however, sums up well what I call the 'ethical turn'. The state of exception is a state that erases the difference between henchmen and victims, including even that between the extreme crimes of the Nazi State and the ordinary everyday life of our democracies. More horrific than even the gas chamber, the true horror of the camps, writes Agamben, occurred during the hours when nothing was happening and the SS and the Jews of the *Sonderkommando* played football together.[53] And every time we turn on our television sets to watch a football match this game is replayed. All differences simply disappear in the law of a global situation. As a result, this situation comes to appear as the accomplishment of an ontological destiny that evacuates the possibility of political dissensus and the hope of future salvation, bar the advent of an improbable ontological revolution.

This tendency of differences in politics and right to disappear in the indistinctness of ethics is also defining of a certain present of the arts and of aesthetic reflection. Similar to the way in which the combination of consensus and infinite justice blots out politics, arts and aesthetic reflection tend to redistribute themselves between a vision of art whose purpose is to attend to the social bond and another of art as that which interminably bears witness to catastrophe.

The creative arrangements with which art intended to bear witness to the contradiction of a world marked by oppression some decades hence, today point to a common ethical belonging. For instance, let us compare two works produced thirty years apart that exploit the same idea.

[53] Giorgio Agamben, *Remnants of Auschwitz: The Witness and the Archive*, trans. D. Heller-Roazen, New York: Zone Books, 1999 (Italian original, 1998).

During the 1970s, before the end of the Vietnam War, Chris Burden created a work entitled the *Other Memorial*, dedicated to the dead on the other side, to the thousands of Vietnamese victims with neither name nor monument. On the bronze plates of his monument, Burden inscribed Vietnamese-sounding names of other anonymous people randomly copied from the phonebook to give names to these anonymous people. In 2002, Christian Boltanski presented the installation *Les Abonnés du téléphone*.[53a] As mentioned above, it consisted of two large sets of shelves containing phonebooks from around the world and two long tables at which visitors could sit down to consult them at their leisure. Today's installation is still based on the same formal idea as yesterday's counter-monument. It is still about anonymity, but it has a completely different mode of material realization and political meaning. Instead of erecting one monument to counter another, we are presented with a space that counts as a *mimesis* of common space. And whereas yesterday's aim was simultaneously to give names and lives back to those who had been deprived of them by State power, today's anonymous masses are simply, as the artist says, 'specimens of humanity', those with whom we are bound together in a large community. Boltanski's installation, therefore, was a good way of encapsulating the spirit of an exhibition that aimed to be an encyclopaedia for a century of common history – a uniting memory landscape that stands in contrast to the divisiveness of yesterday's installations. Like so many contemporary installations, Boltanski's made use of a procedure that, three decades earlier, had been the province of critical art: the systematic introduction of the objects and images of the world into the temple of art. But the meaning of this mixing together has changed radically. Earlier, producing an encounter between heterogeneous elements

[53a] Boltanski's *Phonebook Customers* was commissioned through the Contemporary Art Society and in 2002 was loaned from the Musée d'Art Moderne, Paris, to the South London Gallery.

would aim to underline the contradictions of a world stamped by exploitation and to question art's place and institutions within that world of conflict. Today, it is proclaimed that this same gathering is the positive operation of an art responsible for the functions of archiving and bearing witness to a common world. This gathering, then, is part of an attitude to art that is stamped by the categories of consensus: restore lost meaning to a common world or repair the cracks in the social bond.

This aim may be directly expressed, as in the programme of relational art, for example, whose essential aim is to create community situations that foster the development of new forms of social bond. It is even more evident in the way that exactly the same artistic procedures have changed in meaning, even when used by the same individual artists, as in Jean-Luc Godard's use of collage, a technique combining heterogeneous elements that appears repeatedly throughout his career as a film director. In the 1960s, however, he did this in the form of a clash of contraries, notably that between the world of 'high culture' and the world of the commodity: Fritz Lang's account of a filming of *The Odyssey* and the brutal cynicism of its producer in *Le Mépris*; Élie Faure's *History of Art* and the advertisement for *Scandale* corsets in *Pierrot le fou*; the petty calculations of the prostitute Nana and the tears of Dreyer's *Joan of Arc* in *Vivre sa vie*. In his films of the 1980s, Godard apparently remained faithful to collage as a principle for linking heterogeneous elements. But the form of the collage changes: what was once a clash of images becomes a fusion. And what that fusion of images simultaneously attests to is the reality of an autonomous world of images and its community-building power. From *Passion* to *Éloge de l'amour*, or from *Allemagne année 90 neuf zéro* to his *Histoire(s) du Cinéma*, the unforeseeable encounter of cinematic shots with the paintings of the imaginary Museum, of the images of death camps and literary texts taken against their explicit meaning, come to constitute one and the same kingdom of images, devoted

to a single task: to give humanity back a 'place in the world'.[53b]

So, on the one hand, there are polemical artistic *dispositifs* that tend towards a function of social mediation, becoming the testimonies, or symbols, of participation in a non-descript community construed as the restoration of the social bond or the common world. On the other hand, however, yesterday's polemical violence tends to take on a new figure. It gets radicalized as a testimony to the unrepresentable, to endless evil and catastrophe.

The unrepresentable, which is the central category of the ethical turn in aesthetic reflection, is also a category that produces an indistinction between right and fact, occupying the same place in aesthetic reflection that terror does on the political plane. The idea of the unrepresentable in fact conflates two distinct notions: impossibility and interdiction. To declare that a given subject is unrepresentable by artistic means is in fact to say several things at once. It can mean that the specific means of art, or of such-and-such an art, are not adequate to represent a particular subject's singularity. This is the sense in which Burke once declared that Milton's description of Lucifer in *Paradise Lost* was unrepresentable in painting. The reason was that its sublime aspect depended upon the duplicitous play of words that do not really let us see what they pretend to show us. However, when the pictorial equivalent of the words is exposed to sight, as in paintings of the *Temptation of Saint Anthony* by artists ranging from Bosch to Dali, it becomes a picturesque or grotesque figure. Lessing's *Laokoon* presents the same argument. Lessing argues that the suffering of Virgil's Laocoön in the *Aeniad* is unrepresentable in sculpture, because its visual

[53b] Godard was director and screenwriter for *Contempt* (1963); he based *Pierrot le fou* (1965) on a novel by Lionel White, *Obsession* (1962); *Vivre sa vie* (1962) was released in the US as *My Life to Live* and as *It's My Life* in the UK. *Passion* (1982) was followed by *In Praise of Love* (2001), *Germany Year 90 Nine Zero* (1991) and *History(s) of the Cinema* (1988–98).

realism divests art of its ideality insofar as it divests the character of his dignity. Extreme suffering belonged to a reality that was, in principle, excluded from the art of the visible.

Clearly this is not what was meant by the attacks, instigated in the name of the unrepresentable, on the American television series *Holocaust* (1978), which caused much controversy by presenting the genocide through the stories of two families. The problem was not said to be that the sight of a 'shower room' caused laughter, but that it was impossible to make a film about the extermination of the Jews by presenting fictional bodies imitating the henchmen and the victims of the camps. This declaration of impossibility in fact conceals a prohibition. The prohibition, however, also conflates two things: a proscription that bears on the event and a proscription that bears on art. On the one hand, it is claimed that the nature of the actions and sufferings in the extermination camps forbids there being any depiction of it for aesthetic pleasure. On the other hand, it is said that this unprecedented event of extermination calls for a new art, an art of the unrepresentable. The task of this art then becomes associated with the idea of an anti-representative demand that becomes the norm of modern art as such.[54] A straight line is thus drawn from Malevich's *Black Square*, the first of which dates from 1915, signing the death of pictorial figuration, to Claude Lanzmann's film *Shoah*, completed in 1985, which handles the theme of the unrepresentability of extermination.

It must, however, be asked in what sense this film belongs to an art of the unrepresentable. Like any other film, it depicts characters and situations. And like so many others, it immediately sets us in a poetic landscape, in this case a river meandering through fields on which a boat is rocking to the rhythm of a nostalgic song. The director himself introduces this pastoral episode with a provocative

[54] Gérard Wacjman, *L'Objet du siècle*, Paris: Verdier, 1998.

statement, announcing the fictional nature of the film: 'This story starts in our time on the banks of the river Ner in Poland.' So the alleged unrepresentability of extermination does not mean that fiction cannot be used to confront its atrocious reality. This is very different from the argument presented in Lessing's *Laokoon*, which instead was grounded in the distance between real presentation and artistic representation. On the contrary, it is because everything is representable, and that nothing separates fictional representation from the presentation of reality, that the problem of presenting the genocide arises. This problem is not to know whether or not one can or must represent, but to know what one wants to represent and what mode of representation is appropriate to this end. Now, for Lanzmann, the essential feature of the genocide resides in the gap between the perfect rationality of its organization and the inadequacy of any explanatory reason for that programming. The genocide is perfectly rational in its execution, and even planned to eradicate its own traces. But this rationality itself does not depend on any sufficient rational link between cause and effect. What makes fictionalized accounts of the Holocaust inadequate, then, is this gap between two types of rationality. Such fictions show us the transformation of ordinary persons into monsters, and of respected citizens into human rubbish. It thereby obeys a classical representative logic according to which characters enter into conflict with one another on account of their personalities, the aims they pursue, and the ways in which they are transformed in accordance with the situation. Well, such logic is condemned to miss both the singularity of this rationality and the singularity of its absence of reason. By contrast, there is another type of fiction that proves to be perfectly appropriate for the 'story' that Lanzmann wants to tell, i.e. fictional inquiry, the prototype of which is *Citizen Kane* (1941): this form of narration revolves around an unfathomable event or character and attempts to grasp its secret, but at the risk of encountering only the emptiness of the

cause or meaninglessness of the secret. In the case of Kane, this is the snow that falls in its miniature glass dome, and a name on a child's sleigh. In the case of the Shoah, it is an event beyond any cause that could be rationally reconstructed.

The film *Shoah* is therefore not to be opposed to the televised *Holocaust* in the way that an art of the unrepresentable is to an art of representation. The rupture with the classical order of representation does not translate into the advent of an art of the unrepresentable. On the contrary, it is a freeing up with regard to the norms that prohibited the representation of Laocoön's suffering and the sublime aspect of Milton's Lucifer. These norms of representation defined the unrepresentable. They prohibited the representation of certain spectacles, required that a particular type and form be given to each particular type of subject, and demanded that the actions of characters be deduced from their psychology and situational circumstances, in accordance with the plausibility of their psychological motivations and the existence of causes and effects. None of these prescriptions applies to the kind of art to which *Shoah* belongs. It is not the unrepresentable that stands in contrast to the old logic of representation. Instead it is the elimination of a boundary that restricts the available choice of representable subjects and ways of representing them. An anti-representative art is not an art that no longer represents. It is an art whose choice of representable subjects and means of representation is no longer limited. This is the reason why the extermination of the Jews can be represented without having to deduce it from the motivation attributable to a character or the logic of a situation, without having to show gas chambers, scenes of extermination, henchmen or victims. And this is also the reason why an art representing the exceptional character of the genocide without any scenes of extermination is contemporary with a type of painting made purely of lines and squares of colour as well as with a type of installation art that simply re-exhibits objects or images

borrowed from the world of the commodity and ordinary everyday life.

To invoke an art of the unrepresentable, it is therefore necessary to pluck this unrepresentable from a realm other than that of art itself. It is necessary to make the forbidden and the impossible coincide, which supposes two violent theoretical gestures. First, religious interdiction must be introduced into art by transforming the prohibition on representing the Jewish God into the impossibility of representing the extermination of the Jewish people. Second, the surplus of representation inherent in the ruin of the representative order must be transformed into its opposite: a lack or an impossibility of representation. This presumes that the concept of artistic modernity be construed in such a way that it lodges a prohibition within impossibility by turning modern art as a whole into an art constitutively dedicated to testifying to the unrepresentable.

One concept in particular has been used extensively for this operation: the 'sublime'. We have seen how Lyotard reconstrued it for such ends. We have also seen the conditions required for that reconstruction. Lyotard had to invert not only the meaning of the anti-representative rupture but also the very meaning of the Kantian sublime. To place modern art under the concept of the sublime requires inverting the limitlessness of both the representable and the means of representation into its opposite: the experience of a fundamental disagreement between sensible materiality and thought. This presupposes first identifying the play of art's operations with the dramaturgy of an impossible demand. But the meaning of that dramaturgy is also inverted. In Kant's work, the sensible faculty of the imagination experienced the limits of its agreement with thinking. Its failure marked the limits of its own nature and opened up to the 'limitlessness' of reason. It thereby also signalled the passage from the aesthetic to the moral sphere. Lyotard makes this passage out of the realm of art the very law of art. But he does this at the cost of inverting the roles. No longer is it the faculty of sensation

that fails to live up to the demands of reason. On the contrary, now it is spirit which is faulted, summoned to pursue the impossible task of approaching matter, of seizing the sensible in its singularity. But the singularity of the sensible in fact gets reduced to the indefinitely reiterated experience of one and the same debt. As a result, the task of the artistic avant-gardes consists in repeating the gesture that inscribes the shock of an alterity which initially appears to be that of sensible quality, but ultimately reveals itself to be identical with the intractable power of the Freudian 'Thing' or the Mosaic law. The 'ethical' transformation of the sublime means exactly this: the joint transformation of aesthetic autonomy and Kantian moral autonomy into one and the same law of heteronomy, into one and the same law whereby imperious command is assimilated to radical factuality. The gesture of art thus consists in testifying indefinitely to the infinite debt of spirit with respect to a law that is as much that of the order of Moses' God as it is the factual law of the unconscious. The fact of matter's resistance becomes a submission to the law of the Other. But this law of the Other, in its turn, is only our subjection to the condition of being born too early.

This overturning of aesthetics into ethics obviously cannot be grasped in terms of art's becoming 'postmodern'. The simplistic opposition between the modern and the postmodern prevents us from understanding the transformations of the present situation and their stakes. It forgets in effect that modernism itself has only ever been a long contradiction between two opposed aesthetic politics, two politics that are opposed but on the basis of a common core linking the autonomy of art to the anticipation of a community to come, and therefore linking this autonomy to the promise of its own suppression. The very word avant-garde designated the two opposing forms of the same knot joining together the autonomy of art and the promise of emancipation it contained, sometimes in a more or less confused way, at other times in a way that

more clearly revealed their antagonism. On the one hand, the avant-garde movement aimed to transform the forms of art, and to make them identical with the forms for constructing a new world in which art would no longer exist as a separate reality. On the other, the avant-garde preserved the autonomy of the artistic sphere from forms of compromise with practices of power and political struggle, or with forms of the aestheticization of life in the capitalist world. While the avant-garde movement was a Futurist or constructivist dream to work towards art's self-suppression in the formation of a new sensory world, it also involved a struggle to preserve the autonomy of art from all forms of power and commodity aestheticization. This was not at all in order to preserve it for the pure enjoyment of art for its own sake but, on the contrary, as the inscription of the unresolved contradiction between the aesthetic promise and the realities of oppression in the world.

One of these politics died out in the Soviet dream, although it lives on in the more modest contemporary utopias of the architects of new cities, of designers reinventing a community on the basis of new urban design, or the 'relational' artists introducing an object, an image or an unusual inscription in the landscapes of 'difficult' suburbs. This could be called the 'soft' version of the ethical turn of aesthetics. The second was not abolished by any kind of postmodern revolution. The postmodern carnival was basically only ever a smokescreen hiding the transformation of the second modernism into an 'ethics' that is no longer a softened and socialized version of the aesthetic promise of emancipation, but its pure and simple inversion. This inversion no longer links art's specificity to a future emancipation, but instead to an immemorial and never-ending catastrophe.

Testifying to this is the pervading discourse in which art is placed in the service of the unrepresentable and of witnessing either yesterday's genocide, the never-ending catastrophe of the present, or the immemorial trauma of

civilization. Lyotard's aesthetic of the sublime is the most succinct formulation of this overturning. In the tradition of Adorno, he summons the avant-garde to retrace indefinitely the line separating artworks proper from the impure mixtures of culture and communication. The aim, however, is no longer to preserve the promise of emancipation. On the contrary, it is to attest indefinitely to the immemorial alienation that transforms every promise of emancipation into a lie that will only ever be achieved in the form of infinite crime, art's answer to which is to put up a 'resistance' that is nothing but the endless work of mourning.

The historical tension between the two figures of the avant-garde thus tends to vanish into the ethical couple of a community art dedicated to restoring the social bond and an art bearing witness to the irremediable catastrophe lying at the very origin of that bond. This transformation reproduces exactly the other transformation according to which the political tension of right and fact vanishes in the couple formed by consensus and the infinite justice wielded against infinite evil. It is tempting to say that contemporary ethical discourse is merely the crowning moment of the new forms of domination. But this would be to pass over an essential point: if the soft ethics of consensus and the art of proximity are the ways in which yesterday's aesthetic and political radicality have been adapted to contemporary conditions, then the hard ethics of infinite evil and of an art devoted to the interminable mourning of irremediable catastrophe, by contrast, emerges as the exact overturning of that radicality. Enabling that overturning is the conception of time that ethical radicality inherited from modernist radicality, the idea of a time cut into two by a decisive event. For a long while, that decisive event was that of the revolution to come. With the ethical turn, this orientation is strictly inverted: history becomes ordered according to a cut in time made by a radical event that is no longer in front of us but already behind us. If the Nazi genocide lodged itself at the core of philosophical, aesthetic and political thinking some four or five decades after

the discovery of the camps, the reason is not only that the first generation of survivors remained silent. Around 1989, when the last remaining vestiges of this revolution were collapsing, the events until then had linked political and aesthetic radicality to a cut in historical time. This cut, however, required that the radicality, could be replaced only by genocide at the cost of inverting its meaning, of transforming it into the already endured catastrophe from which only a god could save us.

I do not mean to say that today politics and art are totally subject to this vision. It would be easy to cite forms of political action and artistic intervention that are independent from, or hostile to, that dominant current. And that is exactly how I understand it: the ethical turn is not an historical necessity, for the simple reason that there is no such thing. This turn's strength, however, resides in its capacity to recode and invert the forms of thought and attitudes which yesterday aimed at bringing about a radical political and/or aesthetic change. The ethical turn is not a simple appeasement of the various types of dissensus between politics and art in a consensual order. It appears rather to be the ultimate form of the will to absolutize this dissensus. The modernist rigour of an Adorno, wanting to expurgate the emancipatory potential of art of any form of compromise with cultural commerce and aestheticized life, becomes the reduction of art to the ethical witnessing of unrepresentable catastrophe. Arendt's political purism, which ventured to separate political freedom from social necessity, becomes a legitimation of the necessities of the consensual order. The Kantian autonomy of the moral law becomes an ethical subjection to the law of the Other. Human rights become the privilege of the avenger. The saga of a world cut into two becomes a war against terror. But the central element in this overturning is without doubt a certain theology of time, the idea of modernity as a time destined to carry out an internal necessity, once glorious, now disastrous. This is the conception of time cut into two by a founding event or by an event to come.

Breaking with today's ethical configuration, and returning the inventions of politics and art to their difference, entails rejecting the fantasy of their purity, giving back to these inventions their status as cuts that are always ambiguous, precarious, litigious. This necessarily entails divorcing them from every theology of time, from every thought of a primordial trauma or a salvation to come.[55]

[55] This text was presented in March 2004 in Barcelona at the Forum of the Caixa, which focused on 'Geographies of Contemporary Thought'.

Index

Index

collage 46–7, 49, 122–3, 126–7; counter-aesthetics 100–3; and critical art 46; ethical turn 109–32; 'third way' micro-politics 50–1; and undecidability 59, 60, *see also* metapolitics and aesthetic education
'post-utopian' art 19–22
postmodernity: and age of cinema 83; and ethical turn 128–9; and Lyotard 103; and rupture 42, 49
power: of 'form' over 'matter' 31, 32, *see also* domination
Prénom Carmen (film) 57–8
presence of art 19, 20
Proust, Marcel 5, 68
public as recipients of art 9, 10
purity and politicization of art 32–4, 40–1, 101–2

radicality of art 19, 20, 21–2, 28, 58, 130
Ray, Charles 53
reason: Lyotard and sublime 93, 127–8; rationality of Holocaust 125; and Stendhal 6
'reign of the Law' 32
relational art 21, 22, 23–4, 29, 122, 129
religious interdiction and unrepresentable 127
representation: of unrepresentable 126, 127, *see also* unrepresentable and ethical turn

representative regime for identification of art 7, 29, 65
resistant form 105; politics of 36, 39–43
revolution: aesthetic revolution 36–9, 43; of producers and metapolitics 33–4, 43
rights and national communities 116–17
Rimbaud, Arthur 79, 85
Romanticism 11; and Badiou's inaesthetics 71–3, 80; and confusion in aesthetics 3, 4; educational formation 74
Rosler, Martha: *Bringing the War Home: House Beautiful* 47, 52
rupture and works of art 8–9, 10

salvation, waiting for 43, 118, 120, 132
Schaeffer, Jean-Marie 2–3, 4, 9
Schelling, Friedrich Wilhelm Joseph von 5, 9, 37, 82
Schiller, Friedrich von 8, 14; aesthetic education and *Juno Ludovisi* 27–32, 34–6, 40, 50, 98, 100; and Kantian aesthetics 97–9; and Lyotard 100, 102, 104–5
Schlegel, August Wilhelm von 11
Schopenhauer, Artur 8
'self-containment' of artworks 27–32